The Watercolorist's Essential Notebook

Keep Painting!

Gordon MacKenzie

NORTH LIGHT BOOKS
CINCINNATI, OHIO
artistsnetwork.com

Contents

Introduction...5

1 In Search of Inspiration......................6
Deciding what to do when starting is the hardest part.

2 Composition...12
Constructing art that is both intellectually and emotionally satisfying.

3 Gradations and Reversals................46
Adding variety and realism to your paintings by using these two often ignored aspects of the natural world.

4 Mingling Colors and Passages.........60
Letting the magic of watercolors and the imagination of the viewer create a more engaging experience for you and them.

GOOD MORNING
11" × 14" (28cm × 36cm)

DISTANT SHORES
11" × 22" (28cm × 56cm)

5 Atmospherics 72
Using climatic conditions to set the stage for your visual drama.

6 Wee People 84
Giving life to your pictures by adding a few little figures of interest.

7 Working with Photographs 92
Exploring the creative potential of reference photos when the imagination and daring are fully engaged.

8 Passing On the Spirit by Teaching Others 130
Nurturing artistic growth in yourself and in others by sharing what you have learned.

Index .. 140
About the Author .. 143

FAMILY REUNION
14" × 22" (36cm × 56cm)

WHAT DO YOU WANT TO SAY?
It is permissible to have fun with your pictures, and sometimes that means saying more than what's obvious with your paints. This one is called **Family Reunion**, and I have used stylized trees as the characters in my little drama. Can you find the black sheep, the grandparents, the eccentric aunts and uncles, cousins, the parents, children—and, oh, their pet rock?

Introduction

This book may be dangerous to open. It will at times ask you to use your own judgment, imagination and ingenuity to generate your own picture ideas. There are some step-by-step demos throughout wherever I felt the need for clarity, but often I rely on your intelligence and experience to carry on without training wheels.

This book is really intended for those who have painted for a while but feel they are up against a wall and need a creative kick in the pants, or for those who have set their paints aside for a while because the process has lost its excitement and appeal.

I understand completely.

I have five ideas I want you to keep in mind while you read this book:

1. You don't have to paint the way you paint now.
2. You don't have to paint what you paint now.
3. You have no one to please but yourself.
4. Growth can only come from a positive attitude amid persistent stumbles.
5. Your creative spirit that is still with you is waiting for you to try out your new wings.

This book is not written to showcase what I can do, but to make you aware of options, opportunities and variations that *you* can do.

I want to offer ideas that you can take and run with, that you can explore and develop and use in your own way. I want to encourage you to try some new approaches as starting points for a whole new painting adventure.

Later on in this book is a section on how to use photographic reference material creatively, but the ideas presented will work with any original idea or sketch you have. Before we get to that section, we will explore a wide range of compositional options and painting approaches that you have at your disposal.

It is my sincere wish that with a resharpened focus on your painting, you will come to realize that the process itself is merely a bridge or vehicle you use to reach a broader and richer experience of life, and that by satisfying your very nature to be creative, you are connecting to all others of like spirit and purpose.

When you sense that something at your very core is changing, you will realize that painting is as much about discovering and using your true nature as it is about making pretty pictures.

Painting then becomes the outward activity for tapping into the personal landscapes our memory and imagination have created on our soul and making our "self" visible.

1 In Search of Inspiration

Much of this book provides "how-to" information on the physical aspects of creating a painting. I would be remiss, however, if I didn't say something about an equally important creative process that goes on in our head.

SURF RIDER
19" × 22" (48cm × 56cm)

The Big Picture

Let's look at the big picture first. As we make progress in our painting journey, we tend to work through two general stages.

THE INITIAL STAGE: PAINTING WHAT YOU SEE

This is the most common approach to painting. At this level you carefully observe the lines, colors, shapes, lighting, values and so on in the subject before you, or in a photo, and then try to get it onto the paper as it appears. You may eliminate, emphasize or rearrange certain aspects to improve the final image, but essentially what is in front of you goes on the paper. This attempt to capture the moment and place is the way most of us paint most of the time, and if you are a beginner, it is the recommended approach because it forces you to develop observational skills, experience with composition and expertise in a wide range of basic techniques. You may wish to paint this way for the rest of your life and be quite happy and successful, and that's fine.

However, many artists start feeling stifled once they have painted this way for some time. They need a new idea or a new approach, a new way to get excitement into their work. Maybe if they learned one more tricky technique, or bought new brushes or colors, it would solve the problem. But these solutions don't last. They can't escape the annoying little voice that keeps telling them there is another way to do it, a better way to do it, and they get discouraged. They even have vague, fleeting images of what their work could look like flashing across their minds, or they see a freshness in other people's work and wish they had thought of that.

THE SECOND STAGE: USING YOUR IMAGINATION

Those images and feelings that keep calling you are an invitation. It's your creative spirit that knows you are ready to come out and play. It wants you to go further, to go beyond the literal interpretation of a subject to something that speaks of things not seen by the eye, but by the soul and the imagination. It wants you to be quiet and let the spirit of the subject and your ingenuity create something bigger, more powerful, more profound than just a painted photograph. This is the second level where painting what is seen morphs into painting what you want to see. It's about painting what you would like to feel or have the viewer experience, and it comes from within you. Now the subject is only a catalyst that, with your imagination, opens the doors to endless exciting ideas and images.

But there is a price of admission. If you dabble at this level, you'll need to be daring; you'll need to ignore what others think and be willing to take risks and trust your innate creative abilities.

If this second stage sounds familiar, then the following will be of interest to you.

THE ANSWER IS INSIDE YOU

We are more than flesh and bones. We are far more capable and wondrous than we can ever imagine. The arts—be it literature, music, sculpture, visual arts, dance and so on—prove this. Their expression, in all forms, is concrete evidence of our humanity and an expression of the truth of who we really are. Through the ages the arts have been trying to tell us about our true identity, the best we can be, our higher self.

Painting what you see

Painting what you want to see

Our creative spirit is a manifestation of that higher self. It is a wellspring of originality and ingenuity unleashed by imagination, where anything is possible. Imagination is our most powerful tool in exploring our world and ourselves because it brings to bear the influences of our own life experiences, preferences and feelings in its expression. It explains why we each have our own visions, solutions and sense of what is right and beautiful, and are then driven to express it.

Our higher self, that creative spirit, speaks to us as "intuition," a gut feeling that guides our perceptions. It is the first sense on the scene and gives us hunches and insight, not based on facts and information but on how a situation makes us feel.

"Subtle" would be the best word to describe the messages that come suddenly and without fanfare. They are so quiet, in fact, that they are easily missed, ignored or drowned out by distractions and a critical left brain ready to condemn anything out of the ordinary.

HOW DO WE ACCESS OUR HIGHER SELF?

To access our higher self, we build a bridge. That bridge or gateway to our higher self and our creative spirit is our frame of mind. It's our *attitude*. When we honestly focus our attention and intend on being more open, more original, more personal and especially more receptive to our intuition, we are attempting to be in a higher state of being with our creative spirit. That's the positive force from within that wants to help us solve problems and create things using our "imagination." It's that urge to create that keeps us coming back.

Of course you are not going to get much guidance if you haven't first defined a problem you want help with. This is what you focus on when you listen ever so carefully to the silence. At first it may only seem as if you are talking to yourself—which you really are—but as you mull over your problem, subtly, amid the mishmash of discordant thoughts, little hints or clues or possibilities will start appearing that you hadn't thought of before, because listening to the right side of your brain unlocks your imagination. It may be a gut *feeling* kind of answer, or an *image* or an *impression* or *awareness* of an action

"It's OK—it's just Margaret using her higher self again."

or a whole concept. Expect more than one answer, but do not expect *words*. Our higher self is nonverbal.

Don't expect a complete set of step-by-step instructions on how to save the world. It's not Wikipedia.

This mildly altered state of consciousness is our gateway or bridge to our higher self, our creative spirit. It's that positive force from within that wants to help us create. Those who practice meditation will understand this process.

Do you remember as a child how no one had to show you how to make a picture? You intuitively knew how to compose it. You can still do that today if you just start listening again to that quiet little voice that tells you what "feels" right. That's your key—asking the question, "What feels right?"

So, the next time you have to make a decision about composition, for example, try quieting your mind, focusing on the picture, putting your pencil on the paper and asking, "What would make it *feel* right?" Then follow the subtle internal prompts.

Be patient. It takes practice, but the more you access and trust your intuition, the faster and more easily it comes.

Using your intuition is about waking up to what your higher self is trying to tell you, but most of all, it's about being receptive and less judgmental toward your own ideas, images and solutions.

THE IMPORTANCE OF A CHALLENGE

I always try to have some small problem to work through in every painting. It doesn't have to be earth-shattering but challenging enough that I have to use my ingenuity

Not so fast, inner judge . . .

Much has been written about the strengths of our left and right brain. It is enough to know that the left side excels in matters of logic, linear (step-by-step) thinking and spoken language, while the right brain prefers imaginative, holistic (the big picture), emotional, nonverbal communications. Regardless, it's best to think of both sides working equally in tandem, especially while painting. Here we need to move freely between our art knowledge and experiences with techniques and an open, free-spirited imagination. It is here where we find creative solutions by listening to our intuition and following up with learned art skills.

ASIDE: IT'S JUST KETCHUP
Our left brain deals with reality while the right brain, not knowing the difference, deals with emotions. We think of the right side of the brain as weak, but in fact, it can have a powerful effect on us. For example, when we go to a movie that involves fantasy, such as a sci-fi thriller, we know that the story presented is not real but we nonetheless willingly leave our left brain at the door and proceed to have ourselves emotionally drained by the film. Our left brain may be shouting "It's just ketchup! It's just ketchup!" but we let our right brain believe it's blood in order to fully entertain ourselves. It's always a wee bit of a mental shock and letdown when we leave the theater and reenter reality.

WHEN DO I USE INTUITION IN THE PAINTING PROCESS?
Right from the start.

DURING THE INITIAL PLANNING
Some people search for a painting idea by going through sketches and photos. Some go for long, quiet walks or listen to music. Regardless, when you set the stage and are

Children are usually at home in their right brain.

At the movies, your left brain is left at the door.

to solve it. I feel that if there is a problem to solve, an opportunity to be inventive, I always have far more interest in the painting. I find that if I am trying something new for the first time, there is always a freshness or uniqueness to the work. I have also found that when I try a new approach, it will usually spawn other options that I can follow or bookmark for later. When I start repeating myself and losing interest in a work, it's because there is no challenge left and I know I must search for another.

THE IMPORTANCE OF PLAY
Someone once said, "Play is the best way to learn, short of torture."

In childhood we learned much about our world by suspending reality and playing. Whether pretending, role playing or listening to fairy tales, we loved slipping into the private little make-believe world of our right brain. We still do. It is there that our inquisitive, nonjudgmental frame of mind can make profound discoveries about ourselves and the world. Learning to play with water, brushes and colors is the best way to learn about watercolors. We might call it "experimentation," but it's still play and most valuable to our growth.

eager for a new idea, your imagination and memories can feed you a stream of possibilities if you are receptive (nonjudgmental) and don't stop with the first idea. The trick is to grasp and record what you can from those fleeting images that morph across your mind. It doesn't matter if it's a sketch, a few words or a descriptive list of colors—whatever will help you remember the ideas. Let your gut feeling guide your choices in this initial stage.

On many of my outdoor workshops I have told the participants to make full use of the freedom they have with the subject. I encourage them to continually ask themselves the question, "What if . . . ?" or, "Why not . . . ?" What if I changed the lighting, or the colors or the arrangement of things? Why not leave out or include figures, or change the values, etc., if I feel it will make a stronger picture? The answer to these questions demands the use of imagination, logic (art knowledge) and intuition.

An additional question to ask is, "If not now, then when?" When will I be bold enough to express myself in a painting? All of these questions are of course also tied to the question, "What feels right?" If you change the colors, what feels most appropriate? If you add figures, where does it feel right to put them? Intuition, therefore, plays an important role right from the very beginning.

DURING THE PAINTING PROCESS
As soon as you choose the size and format of your picture, you have started making decisions which open the door to your intuition. What we must guard against is always making the same decisions without ever considering the options.

Perhaps you can remember the old TV commercial for V-8 cocktail vegetable juice where a fellow goes to the refrigerator after having a can of soda, slaps his forehead and says, "Wow! I could have had a V-8."

There is a parallel.

Our paintings are not so much the result of our achievements as they are the cumulative effect of self-imposed limitations. When I say limitations, I don't mean physical limitations or skill level. I'm talking about the things we handicap ourselves with, without even knowing. This is because we are creatures of habit and unintentionally or conveniently make the same choices every time we set off to paint. Without realizing it, we limit how we see our subject matter (always the same ground-level realistic point of view, same time of day, same weather, same subject, same amount of detail, same literal values, same, same, same), we limit how we compose our work (same major horizontal/vertical line position; same background, middle and foreground layout; same color scheme; same reliance on luck for atmosphere;

I had a really good idea for a painting once. I know that it would have been great . . . if I had just written it down.

same lack of attention to movement; same; same; same) and, to a lesser degree, we limit how we work with the medium and the tools (using the same brush in the same way regardless of the task, the same tired techniques without variation, same, same, same). But the greatest option and gift that we fail to exercise most is intuition and imagination. What if we set ourselves free to do so? What if we listened to that wee inner voice

Don't go into battle without Imagination and Logic at your side.

and turned on innovation? What if we challenged ourselves with a problem that we had to solve in every picture?

The point is this: out of all our self-imposed limitations come the styles we each have now, and our pictures are the result of what we didn't do, the choices we didn't make.

Undoubtedly the awareness of our options comes with experience, but exercising them comes with a challenge, excitement and risk. But, this is the only way we'll knock down barriers, climb out of our ruts and discover other ways of seeing and capturing a subject. We may even turn some walls into doorways or water into V-8.

WHEN YOU'RE FINISHED
Maybe it's too late in the painting process to use your intuition. All it can do now is congratulate you or tell you what you should have done instead.

IN SUMMARY
Whether you choose to open this door into yourself and tap into the inspiration and knowledge found therein is up to you.

I can only say that if you want to move into the second stage of painting, you'll need to look inward. There you'll find, as so many other artists before you have, an endless source of images and ideas. You'll see your subject in a new light, with new eyes, with new possibilities.

You'll become inspired to try different approaches with old subjects and find renewed excitement and enjoyment in your creative journey, and all without your teeth falling out.

Finally, I've been wondering why intuition always seems to provide answers, solutions, directions to follow and choices to make, but never seems to ask any questions. I suppose that might be a bit unnerving, but that brings me to my last point.

CLARIFICATION
In previous statements I may have described intuition as "a quiet little voice" that "speaks" to you. Let me point out that I don't mean an actual voice per se, but the feelings or impressions that you sense internally.

So, if you are sitting with paper and pencil in hand waiting anxiously to hear someone speak, forget it. On the other hand, if you are really hearing voices, perhaps a book on psychic channeling would be more in order.

You may be in for a long wait . . .

2 Composition

The most effective pictures reach the viewer at an emotional level as well as intellectual. These are the pictures that cause viewers to reflect, see another reality, laugh, dream, empathize and even weep because they are taken well beyond a few layers of paint to a place most private and personal. Composition is a major part of that process.

NETHER WORLD
14" × 22" (36cm × 56cm)

Constructing Your Picture

How you arrange and present everything you put in your picture is called *composition*. It's something common to all creative endeavors. It's no coincidence that a musical composer refers to their piece of work as an "arrangement," or that a poet chooses and arranges their words carefully. Even chefs in fine restaurants know that arrangement and presentation is everything. If they just slopped the food on your plate, they would soon lose their reputations regardless of the quality of the food. Likewise, if you just slop the paint on your paper without any thought whatsoever as to where it goes or the final effect, you may be depending too heavily on happy accidents and a very gullible public. Intuitive decisions are not based on luck.

As artists our objective is to get our viewers to see what we want them to see. It helps to not lead them astray with undue distractions once you have their eyes on the paper.

This involves:

1. Knowing what attracts our eye and using this to establish a focal point and center of interest.
2. Knowing how to inject energy or dynamics by using movement and atmospherics.
3. Knowing what kind of distractions can lead the viewer's eye astray.
4. Realizing that even while working with the subject before you, you still must compose.
5. Knowing what tools we have to create the effects needed to achieve the above. We call these tools the elements of design, and the effects you can create with them the principles of design.

Presentation is everything.

Not a hard choice to make.

Every morning Wanda must compose herself.

NOTE

Later on in the book we will explore the many ways of using photographs. Many of the changes we can make will involve changes to a photograph's composition. By looking at that aspect of picture making now, we will save time and repetition later.

THE ELEMENTS AND PRINCIPLES OF DESIGN

Earlier in this book I point out the importance of our innate creative abilities to make intuitive decisions when it comes to composition. I still believe that the painting process is but a bridge to a higher self or creative spirit that can guide us to our greatest potential. However, this is not in conflict with a good working knowledge of the elements and principles of design and, in fact, makes our intuitive decisions more informed. For example, if I were having brain surgery, I would trust the intuitive decisions of someone with medical training over a man off the street.

The *elements of design* are the visual tools we have at our disposal. The most important ones are color, line, shape and value.

The *principles of design* are the visual effects we can create with these tools, the main effects being unity, dominance (or emphasis), variety, contrast, mood, gradation,

13

transitions, perspective, balance, rhythm and movement, pattern and any other visual effect that you can think of by manipulating the elements.

For example, we can create mood by varying *color* and *values*, suggest perspective using converging *lines* and varying *values* and sizes of *shapes* or imply movement and energy by the way we position our *lines* and *shapes*.

WHAT'S MORE IMPORTANT?

Of all the principles, unity—that sense of completeness or wholeness in your painting—is the one thing we most want to achieve. That is done primarily by creating dominance. That means letting some aspect of an element dominate the picture; however, that dominance must be tempered. To create balance and variety within that dominance, we need to include some of the opposite element.

For example, if you wish to have a warm picture, then your palette will contain mostly a variety of warm colors. If they are all warm, however, the picture may be a bit overwhelming. Smaller amounts of cool complementary color that can be scattered about the picture and mixed with the warm colors will help balance the effect and extend the variety of colors you create.

The real purpose of unity and dominance is to make your painting more attractive by giving it an emotional, dynamic punch. Think of your picture as now having an intriguing personality that keeps viewers coming back for repeated viewings.

MORNING LIGHT, KEGOS
11" × 14" (28cm × 36cm)

GIVING AND TAKING COLOR, LINES AND SHAPES
In this five-minute field demo, the energy from an explosion of morning light coming through the pines was created by periodically wiping off converging rays of light with a stiff damp brush as the paint was being applied with another stiff (hog bristle) brush and a sponge.

PUERTO ESCONDIDO MORNING SURF
7" × 11" (18cm × 28cm)

CREATING MOOD BY MINGLING
The dominantly soft, warm environment in this watercolor field sketch results from the mixing and mingling of warm and cool colors to achieve balance and variety between the colors.

HOW DO YOU ACCOMPLISH IT?

Dominance and the resulting unity is easier to achieve if you choose only one or two of the elements to dominate in your picture. For example, choose one major value (lighter or darker) and one major type of line (such as curved), while the remaining elements, color and shape, play supporting roles.

On the next few pages are some examples of how various elements dominate to create unity.

MICA BAY
14" × 22" (36cm × 56cm)

CREATING UNITY USING COMPLEMENTARY COLORS
Warm light is made a dominant feature here by having the shafts of light and reflections from the water contrast the mid-value neutral grays used throughout. Mixing any pair of complements will produce a unique range of related grays. By staying with the same two colors throughout the picture (in this case, Cobalt Blue and Quinacridone Burnt Orange), a sense of unity is produced.

EDGE OF THE CLEARING
14" × 22" (36cm × 56cm)

CREATING BALANCE BY ADDING A BIT OF THE OPPOSITE OF THE DOMINANT ELEMENT
The hard-edged tree trunks dominate with their warm vertical lines. The predominantly dark, congested forest is balanced by the light openness of the clearing, while the warmth of the tree trunks is countered by a touch of intense coolness in the sky.

NOVEMBER MOOD
22" × 14" (56cm × 36cm)

USING LOW-KEY VALUES TO CREATE MOOD AND CONTRAST
This predominantly cool, dark monochromatic picture is shocked by a bit of warmth in the sky and ice. The dark land is intended to invoke mystery and foreboding.

TAMARAC GROVE
14" × 22" (36cm × 56cm)

COLOR TEMPERATURE AND VALUE CONTRAST PRODUCES GLOWING DRAMA
Besides some cool pink, there is very little to contrast this predominantly warm picture. What tempers the effect are pale and dulled yellows in the trees and foreground and a very dark contrasting background that shines a spotlight on the foreground trees.

Visual Perception

We are hardwired to react to certain visual stimuli. It's 100-percent natural, and knowing and using these stimuli in your picture will make composing and painting a lot more effective and fun.

For example, movement attracts our attention. Look out the window; your eye will automatically lock onto anything that moves. If we include some form of movement in our pictures, it too will attract attention and in turn strengthen our compositions.

Most importantly, applying what we know about our natural perception of *contrast* (of value, color, shape and line), *atmosphere* and *movement* will improve the drama of our work. Get control of the drama and you also get control of the viewer and maybe sales (if that's of interest to you).

PERCEPTION OF CONTRAST
In general our eye goes to anything that is out of place or different from its surroundings (the opposite of camouflage).

CONTRAST OF VALUES (LIGHT VS. DARK, DARK VS. MEDIUM, ETC.)
We are naturally attracted to the lightest objects or areas in our field of view. The darker the background or surrounding area, the greater the contrast and the more we are attracted to it. We tend to skip over lesser degrees of contrast, but these play an important role when setting a mood or creating mystery.

PLACE GREATER VALUE CONTRASTS WHERE YOU WANT THE MOST ATTENTION
Our center of interest often involves strong value contrasts. It could be a light object against a dark background or a dark object against a light background. Note how the eye skips over areas of lesser contrast.

VALUES ON THE EDGE
But there is more. In order to ensure that desired shapes are easily visible, we may need to tweak the value of the edges of adjoining shapes for greater contrast. For example, on the right, the upper left corner of the interior box is lightened to contrast the darkened upper left corner of the outer box. This is reversed on the right side. Chapter 3, "Gradations and Reversals," has more on this.

CONTRAST OF COLOR

Colors can contrast each other in terms of their basic characteristics, including hue (the basic color, such as red, yellow or green), value (light or dark), intensity (pure or dull) or temperature (warm or cool), and in reality we most often make the contrast using more than one of these features at a time—for example, pale, dulled blue vs. darker, pure orange, or dark, dull green vs. cool, lighter red-orange.

CONTRAST OF SHAPE AND LINE (EDGES)

We notice shapes and lines that are different from each other and their surroundings. This is a good way to get things of interest to stand out from their surroundings or be subtly hidden in the composition.

TULIP STUDY
11" × 14" (28cm × 36cm)

CONTRASTING COLOR ATTRACTS THE EYE
This picture not only contains numerous forms of color contrast so the flowers stand out, but it is also an example of how our eyes are attracted to neighboring variations of one color and gradations of one color into another. Did you notice how your attention went to the lighter, warm, pure colors before the darker, cool, dull ones?

HOW IS YOUR BACKGROUND AFFECTING YOUR PAINTING?

One of the things you must learn when observing values and colors is to take note of what's in the background that makes them stand out. It all started here for me. I can remember how easy things became when I intentionally started taking note of the backgrounds of my subjects.

PRAIRIE SLOUGH
11" × 14" (28cm × 36cm)

NATURAL VS. MAN-MADE
The straight, hard edges of the buildings and the water in the background contrast the natural irregular edges of the clouds and reeds, but why do the buildings stand out more? In the natural world, man-made shapes attract more attention than natural shapes because they are in the minority; however, in the city that may be reversed and there might be more to it than that. (See pages 40–41 for more on the "pecking order" of what attracts the eye first.)

REPAIRS
11" × 14" (28cm × 36cm)

NATURAL VS. HUMAN
In this field sketch, a man-made fence and the man himself contrast the soft, irregular natural world.

CHANGE CREATES DRAMA

The greatest drama occurs when conditions in nature are in transition—one season into the next, day into night, night into day, one form of weather into another, young into old, and so on. These times provide ample opportunity for contrasts.

The bottom line: If you can't find drama in your subject, create it. You have a license to do that.

BEND IN THE FOG
11" × 14" (28cm × 36cm)

HARD EDGES VS. SOFT EDGES
We are attracted to lines or edges of shapes that are hard over those that are soft or out of focus. Soft edges and shapes which lack strong contrast tend to recede into the distance.

PERCEPTION OF THE ATMOSPHERE

How we see our physical environment affects our emotions. Consider how you feel as the sun breaks out after days of overcast skies or as you watch approaching winter storm clouds.

We can apply these feelings to our paintings by the way we manipulate our colors; however, the environment in a painting is more than what's happening in the sky. It's now the whole pervasive setting for your subject, the background stage in which your subject is immersed.

Creating a specific atmosphere for your painting is one of the most enjoyable and effective ways to add drama and appeal to your composition. It becomes an all-encompassing, unifying feature, one that can instantly engage the viewer at a powerful subliminal level.

How do you do it? By applying what we have observed in nature.

In nature, atmospherics are caused by moisture and dust in the air (clouds, rain, fog, smog, haze, snow, mist, etc.) that in turn affect lighting. That altered lighting affects what we see. By painting accordingly, we can re-create the illusion of the atmospherics you want in your picture.

For example, on a bright sunny day, colors appear pure and value contrasts are extreme (shadows are very dark). We can see more detail and edges are sharper. If we paint that way, we give the illusion of a bright sunny day.

Likewise, to indicate that the humidity is increasing (haze, fog, snow, etc.), we lessen the degree of contrast and make shadows paler,

HEADWATER GLOW
11" × 14" (28cm × 36cm)

CLEAR AND CRISP
This example uses pure warm and cool colors, a wide value range and detail to suggest fresh, clear air.

AUTUMN MIST
11" × 14" (28cm × 36cm)

MOISTURE IN THE AIR
This picture's dulled colors, lack of detail, soft edges and low degree of value contrast indicate high, warm humidity.

start dulling our colors, soften the edges and reduce the amount of detail.

Not affected by moisture but important to the atmosphere's ability to create a mood is the picture's overall temperature (warm, cool or balanced) and overall value (light, medium or dark). These two aspects should be taken into consideration when you first choose your colors and decide on the feeling of the atmosphere you want to create.

PERCEPTION OF MOVEMENT

This is the easiest way to inject energy and excitement into your picture. It can be done in three ways: by implying movement, by actually pointing the viewer's eye to a specific target, or by providing a path for the viewer's eye to follow.

IMPLIED MOVEMENT

Anything that parallels the frame of your picture is seen as stable and balanced—or calm and lifeless. To shake things up, place shapes and lines at an angle to the frame. Curving lines imply more movement and character than straight lines. Objects or shapes suspended in motion will add energy and direction.

WARM AND COOL
11" × 14" (28cm × 36cm)

AN ENVIRONMENT THAT ENGAGES
The pure colors and high contrasts in the upper central part of this picture create a focused sunlit island in the soft, undetailed, ethereal world around it.

STRAIGHT VS. ANGLED
The quality of the shapes and lines affects our perception of the subject. Even slightly angled lines add energy and character to the house.

WARM HEARTED FLORENCE
14" × 22" (36cm × 56cm)

ANGLES CREATE ENERGY
Even an old stove has more energy when angled in the picture.

KEEPING AHEAD OF YOUR WORK
11" × 14" (28cm × 36cm)

AIRTIME ACTION
When objects are suspended, you double the energy by implying an action in perpetual progress. This tractor and the manure will never stop flying.

THAT AUTUMN CROWD
11" × 19" (28cm × 48cm)

FOLLOW THE CURVES
To add life to this forest, all the lines (the tree trunks, the ground, the foliage) are curved or angled except for the straight lines for contrast on the pond.

TANGO IN THE WIND
14" × 22" (36cm × 56cm)

MAGICAL MOVEMENT
We know the invisible wind by the shapes it creates, so when we paint those curvy shapes, the viewer gets to experience the moving air. What kind of magic is that?

Pointing the Way

Many of the objects you put into a painting have a "pointing" quality that can lead the viewer's eye in a specific direction. This can be useful in getting the viewer to see what you want them to see. We must be careful because these objects can also point the viewer's eye right out of the picture.

PARTY POOPER
15" × 22" (38cm × 56cm)

THE ONES THAT GOT AWAY
The direction of the minnows and shafts of light suggest an explosive getaway. The trout's eye tells you where to look.

ARRANGEMENTS WITH MEANING
Can you surmise what the situation is in each of these pictures simply by the way the objects are arranged (pointed)? Can you find: "apathy," "ignored," "conspiracy" and "isolation"? Using this pointing quality of objects is a great way to suggest subliminal messages in your work.

MIROPOIX MARKET, FRANCE
8" × 11" (20cm × 28cm)

BODY TALK
Body language is of great importance when painting figures, and a major part of the language is the direction the figure is facing or pointing. Notice how your eye scans each figure for its activity in this field study. We'll learn more about adding people to our artwork in chapter 6.

When the Path Becomes a Format

You are gaining control of the viewer when you can get their eyes to follow a path in your picture by the way you arrange and position shapes and points of interest. If you now think of that path as a format or structure that you can reuse with variation, in other pictures you'll start seeing fresh new ways of presenting your subjects.

There are two basic types of paths or formats: *enclosed* and *open*.

Enclosed is any path that comes back on itself, such as an oval, triangle or rectangle. These easily keep the eye in the picture.

Open involves the eye moving back and forth on a path, such as a zigzag or a spiral. Care must be taken that you don't lead the eye out of the picture with this arrangement.

The following pages have examples of formats that I have used and reused in numerous paintings. For each format I have shown a tiny sample of the variations possible. These formats are intended to add energy to a picture by getting the viewer's eye to move about it.

You may find yourself using more than one format at a time (for example, big-and-small and zigzag). In time you will develop formats of your own. The format criteria on the next page should help.

OVER MACGREGOR BAY
30" × 19" (76cm × 48cm)

MULTIPLE PATHS
It is possible to have more than one path for the eye to follow in a painting. There are at least two zigzag paths leading your eye into and around this picture. Can you find them? (One is wet; the other, dry.)

CUTIN CORNERS GENERAL STORE
15" × 22" (38cm × 56cm)

A GUIDED TOUR
Pay attention to where your eyes move in this painting. Do you find them following an enclosed path from storefront to truck, to moon, to sign and back to storefront, with the gas pump as a side attraction? We could call this a box or oval format, but the label for this enclosed path doesn't matter. What matters is your eyes were continually led around the picture from one point of interest to another, and at no point did they stray off the paper. What more do you want? The focal point is the place you spent the most time.

FORMAT CRITERIA

These three criteria that were used in the following sample formats will also help to keep your own formats on track:

1. **Pick** a structure (path) that can be varied in size, direction and the breakup of picture space.
2. **Keep** your focal point away from the dead center and the corners or edges of your picture space.
3. **Avoid** having major shapes and lines that run parallel to the edge of the paper. Even a slight change of angle or direction will look better. The exception is the surface of a distant body of water. Then, you definitely want it to be straight and horizontal.

THE HOOK/SPIRAL

In this format I draw a hook shape entering the picture space from one of the sides. There are many variations possible when you enter the picture space from different directions. Because the end of the hook is an ideal location for a center of interest (indicated in blue), I try to have it terminate away from the center and edges of the picture.

ARROWHEAD DRAGON
15" × 22" (38cm × 56cm)

Entering the picture from the bottom, the eye follows a subtle clockwise arrangement of arrowhead leaves to a dragonfly.

THE ZIGZAG

This is a powerful and subtle way to lead the viewer into and around the picture space. Your focal point can be at the zigzag's end or anywhere along it. Try using more than one zigzag in your composition.

DANCING RIVER
15" × 22" (38cm × 56cm)

The edges of the river form two converging zigzags that the eye can't avoid because of the contrasting gradation of value in the river itself. The viewer is pointed toward the distant patch of water, the only horizontal line in the picture.

25

ONE SIDE AGAINST THE
OTHER (BRIDGE)
Here we have two different-sized sides that are reaching out to each other, with a focal point located somewhere in between. Sometimes we call it a "bridge" because the eye is kept busy moving back and forth between the two sides.

THE NARROWS
11" × 14" (28cm × 36cm)

In this format the eye spends most of its time exploring the area where the large pieces of land are closest together. Sometimes they are joined and the eye has a real bridge to run back and forth on.

THE EMBRACEABLE YOU
Sometimes I've used elements of my landscape to frame my center of interest. Framing that embraces or shelters the main subject also keeps the viewer's eye in the picture. This is a wonderful opportunity to break the picture space into interesting unequal portions and create an unusual haven or point of view for your subject.

TURBULENCE
11" × 14" (28cm × 36cm)

Here the trees, rocks and leaves block the rambling eye from leaving the subject—or, are they sheltering it?

PLEASE RELEASE ME,
LET ME GO
Sometimes I've used a framing structure that is open on one side to suggest that the center of interest is at a threshold where it is free to leave or perhaps has just entered the location. Shapes are arranged to provide a visual release or an escape for the center of interest.

NORTHERN DANCE
11" × 14" (28cm × 36cm)

The snow and trees are sharing a celestial dance of freedom with the night sky, and the viewer's eye joins them.

BIG AND SMALL
When a big mass or group of small masses are set against a smaller mass, there is always tension and eye movement between the two. The smaller mass is often a good location for the focal point.

CINQUE TERRA SHORELINE
11" × 14" (28cm × 36cm)

As the eye moves back and forth between the big rocks and the small one, it has a chance to enjoy the patterns on the waves and freshness of the sea.

27

VARIABLE REPETITION

This format is based on a framework created by repeating a line, but each time making a progressive variation on it. This is a powerful format for moving the eye across a sweeping landscape.

Repeat pattern

Repeat pattern with progressive variation

You may find it easier to start with a line in the middle and then develop a pattern by working out from both sides of it. The red lines shown are where I started.

BILLOWS
11" × 14" (28cm × 36cm)

The edges in these clouds are the result of a pattern developed by making repeated variations on a "billowy" line. Note that the lines can vary in length and spacing.

DAWN SYMPHONY
22" × 19" (56cm × 48cm)

The wave pattern in this picture is the result of two repeat curving patterns going in opposite directions.

28

Color Dominance and Unity

Regardless of our painting style or subject or color scheme, it's important that we establish unity in our picture, and one of the easiest ways to do that is through color dominance.

WHERE DO YOU START?
Color dominance is decided during the initial planning stages. While sketching an idea for a painting, either on site or from imagination, the first thing to do is envision the overall *feeling* or *mood* you want in your completed picture.

You know this is achieved through the quality of the colors you use, so start with *temperature*, the most emotionally charged aspect of color. Ask yourself, "Would warm or cool colors best convey the mood that I want, and just how predominant do I want them to be?"

Knowing the temperature and your subject, you can then start choosing single colors or a range of colors for both the warm and cool aspects. One temperature will predominate; the other will contrast and neutralize it for variety. This is when you play on the back of old paintings with color swatches until you find a range of colors you want. That range may fit a color scheme or simply the essence of your subject.

Your second way to interpret feeling or mood is in terms of the *light quality* in your picture. This illusion is created by the *intensity* or *purity* of the colors I use. This was mentioned earlier under "Perception of the Atmosphere" and is worth repeating: Under bright sunlight, colors are pure. As light gets more and more diffused because of moisture, dust, smoke, etc. in the air, the purity of colors decreases. Dulled colors imply subdued lighting and poor visibility.

A decrease in visibility also means a decrease in the degree of value contrast and the amount of detail that may be visible, especially in the distance.

Think of intensity as a volume control on the emotional effects of your colors. Pure colors are emotionally and visually full volume compared to dulled ones. You lower the volume by adding varying amounts of a color's complementary color.

Your final consideration is the overall *value* (lightness or darkness) of your picture. Try to envision it as high key (light), middle key or low key (dark) and decide what would best enhance the mood or feeling you want.

SUMMER RETREAT
11" × 14" (28cm × 36cm)

COLOR THAT GRABS THE EYE
The warm, pure colors that dominate this field sketch create an attention-getting atmosphere.

OTTAWA VALLEY
14" × 22" (36cm × 56cm)

HOW LIGHT CAN AFFECT COLOR
In the real world, light quality determines the purity of colors we see. In this case, the diffused sun reveals dulled colors. It also darkens the overall value of my scene.

THE EMOTIONAL EFFECT OF PURITY
Purity also controls the emotional level of a color. Which heart best says, "I love you"?

29

SOME TIPS ON LIGHT AND DARK

Watercolors have a bad reputation as being too light, washed out and drained of life-giving color.

If you choose to paint high key, keep this in mind: Colors that are tints of pure colors are far more emotionally and visually appealing than tints of dull colors, which may come across as lifeless.

If you wish to mingle colors (as described in chapter 4) and keep them bright, you should use analogous colors or those of the same temperature. Complementary colors will only create dulled colors, unless that's what you want.

Even high-key paintings need good value contrast near the points of interest to turn what could be an anemic painting into one filled with light.

If you choose to paint a low-key painting, keep this in mind: The best dark colors are produced by mixing together dark transparent or semi-transparent colors. Introducing an opaque color into the mixture only produces lifeless mud.

Even in the dark, you want to see some detail. This means building up your dark areas in layers so that subtle shapes in each layer are there for the eye to find. If you mix together all the colors that you plan to use for dark areas and apply it as a single layer, it will lack the transparency and vibrancy of a dark created with layers of medium dark colors. You'll also lose the mystery and intrigue of seeing things in the shadows. If you use one very dark mix for shadows, you also run the risk of laying on a dark that is too dark for the job.

This high-key painting of an autumn hillside lacked punch.

By adding a few darker foreground trees, the picture is still high key but with contrast.

MIXING TIP

The best way to mix dark, intense color is to use less water. That means NOT cleaning your brush every time you want to pick up more color to add to a mixture. Just scrub it in the color you want and go back to the mixture. I know that this goes against all your rules of cleanliness and good housekeeping, but it's the only way to stop adding water to the mixture, which only dilutes it.

Concentrated color is produced by going from color to color to mixture without cleaning the brush in between.

HINT, HINT

If you decide to try more medium to dark value pictures, keep in mind this means using more paint, which won't happen if you don't first put it on your palette.

Shadows as one layer of dark.

Shadows as multiple layers of medium darks.

There Is More Than One Way to Choose Colors for a Painting

BY WHAT WE SEE

Our natural inclination is to use colors that are as close to the observed local colors of our subject as possible. There is nothing wrong with that. We learn a great deal about mixing and matching colors using this approach and find great satisfaction in doing so.

However, if we are painting from observation, we tend to use too many colors, too many variations, without anything being dominant.

What we need to do is restrict the number of colors we use. That's why color schemes were invented (more on those later). They keep us from using every color we own, so that the colors we mix will "feel" related.

BY HOW WE WANT THE VIEWER TO FEEL ABOUT THE SUBJECT

There is a variation on this approach that will allow you to be a little more creative. After all, we are artists, and as such, our colors should reflect our reaction to the subject beyond what is obvious.

Here's the chance to use color not as just a filler for shapes but as a way to reach the viewer at an emotional, subliminal level. The colors shown in the first exercise on this page are not used to decorate but to communicate. Give it a try.

That was easy! People in advertising know very well how to convey a message with colors and bombard us with it. I'll bet, from experience, that you could easily go back and pick out not single colors but combinations that suggest quality, sophistication, inexpensive, alluring, cheap, outdoors, etc.

BY THE ESSENTIAL NATURE OF THE SUBJECT

In doing the second exercise, you will have chosen colors to suit an impression or essence of a subject. They are your personal reaction to it. The choices were not based on what you could see, but what you felt and remembered about the subject or envisioned it to be. Now, try using that same frame of mind when you look at a real subject. Try to envision the colors that would best suit your impression of its character, its essential nature. Start by considering colors that are predominantly warm or cool, pure or dull, light or dark. (This is really about setting a dominance in your picture in terms of your colors.)

Allow yourself to imagine the subject in colors totally different from what they are now. This could mean anything from tweaking the local colors to picking an entirely different set of colors for the whole painting so that they better suit how you see your subject.

Try to be consistent. If you decide to use surreal colors in your picture, use them throughout. Having one realistic color amid a sea of surreal colors is hard on the eyes. Using this approach to choosing colors means that you may not wander too far away from the local colors and yet inject your own take on the subject.

EXERCISE 1: WHAT COLOR CAN CONVEY

Take your time to look at these colors and choose two or three that you think best suggest: youthfulness, spirituality, growth, masculinity, femininity, melancholy, seclusion, maturity, sensuality, earthiness, freshness, airiness.

EXERCISE 2: COLOR ASSOCIATION

Here's another exercise where you freely associate color with a subject. Divide a piece of watercolor paper into six sections. In each section, paint some daubs of the colors you would use to depict or convey the feeling or essence of the indicated topics. You may have to change the value, temperature and purity of your colors as you go.

- Outdoor market
- November walk
- Seashore
- Spring garden
- Desert
- A parade

EXAMPLES
What kind of visual flavors are you putting into that dish you are serving up?

In these examples I have chosen colors that I felt best depicted the feeling or essence of the subject that I was trying to portray.

RIDING SHED TREASURE
15" × 22" (38cm × 56cm)

REFLECTING ON THE PAST IN THE PRESENT
I used warm, dark and dulled colors because they were the real weathered colors of the wagon, but they also reflect a warm history of a simpler bygone day, one that is quickly fading into dark obscurity.

PULSE OF SUPERIOR
15" × 22" (38cm × 56cm)

REVEALING A DIFFERENT SIDE TO THE SUBJECT
Lake Superior's reputation as powerful, cold and dangerous is well earned, but if caught on a hot summer day, it's been known to show a gentler face. Warm, dulled colors were used to capture the light on one of those warm, hazy days on this extraordinary body of water.

AUTUMN WALK
15" × 22" (38cm × 56cm)

MAKING COLORS MORE MEANINGFUL
This picture is a reflection on the multitude of trails and tracks I've walked over the years. Partially defined shapes suggest the ethereal nature of memory reinforced by colors both pale and dark, warm and cool, pure and dull to represent life's varied experiences along the way.

MEADOW WORLD
15" × 22" (38cm × 56cm)

RESURRECTING A MEMORY
In the backyard of my memory is a deep meadow where my chums and I spent many an hour playing hide-and-seek, and I remember lying amid cool and shady grasses and flowers hoping not to be found. The cool, pure and dark colors I used helped me recapture that feeling.

Where Common Palette Colors Fit on the Color Wheel

Choosing colors according to a color scheme (which we'll learn about next) ensures a restricted number of colors are used in the painting, and therefore color harmony is almost guaranteed. Even with the restricted number of colors within a scheme, there is still plenty of room for variations.

The problem with choosing a color scheme is that we tend to think only in terms of the pure, saturated hues on the traditional color wheel.

In reality the colors around us and what we want for our pictures are not always pure and saturated. That means learning to mix and adjust the colors we choose for a scheme into something we want. That also means including unsaturated colors in our schemes if we wish.

The color wheel on this page gives the approximate location of common reliable paint colors, according to their temperature (warm or cool) and their level of saturation.

COLOR SPEAK

When you are looking at a color wheel, you are looking at the pure "hues" derived from a light spectrum. When you're looking at your palette or paint box, you're looking at colors. Those colors are variations on the hues and are usually given a distinguishing name so you'll remember them, such as "Moldy" Green or "Passionate" Purple. Colors made from the pigments that reflect the pure hues are called "saturated." Colors that we use that are not based on the light spectrum are called "earth" or "unsaturated" colors.

33

Color Schemes: A Quick Reference

Using a color scheme improves your chances of creating color harmony and allover picture unity because it restricts the number of colors you use. We must also keep in mind that color schemes represent only saturated hues. This means that in a red/green complementary scheme, any number of different red and green colors could be used, with each pair producing different results (more on this on page 36). However, if you think a color scheme is too restrictive, check out the last one called the "intuitive" scheme.

The important thing about using a color scheme is to stick to the colors you pick. Resist the temptation to add that little bit of rogue color. It can ruin everything.

Except with an analogous scheme, all colors can be dulled or muted or neutralized by mixing them with their opposites (or complements) on the color wheel.

COMPLEMENTARY
Using opposite colors on the color wheel gives you a limited range of mixed colors but guaranteed color harmony. If mixed, they produce dulled or muted forms of each other and some form of gray. If placed next to each other, they produce contrast.

SPLIT COMPLEMENTARY
The extra color provides a bit more range of mixed muted colors than complementary.

DOUBLE COMPLEMENTARY
One additional color offers a bit more variety of colors and a wider range of mixed dulled colors than split complementary.

ANALOGOUS
This is like using a color family, four to five colors located next to each other on the color wheel. This can become overwhelming in one temperature, so try to include one color in the opposite temperature for visual balance and the chance of a few muted colors.

TRIAD
Try primary (red, yellow, blue), secondary (orange, green, violet) or any other three equally spaced colors on the color wheel. You do not have to mix all three together at the same time while painting, but mixing all three will produce the greatest number of grays and muted colors. Which red, which blue and which yellow you use affects the overall mood of the picture.

COMPLEMENTARY ANALOGOUS
Start by choosing an analogous range, then add a complementary color to contrast them. You will get a wide variety of colors and range of muted variants.

FOR ORDERLY RANDOMNESS, TRY AN INTUITIVE SCHEME

This color scheme is for people with an aversion to color schemes. It's off the radar for most folks and books but ironically, and secretively, may be one of the most popular. It doesn't fit the established criteria for schemes because it doesn't rely on a pattern to choose colors. It has no pattern.

This is how it works: We tend to gravitate to colors we like. Here is a chance to use them in a picture. The scheme is based on randomly choosing two or three unrelated colors that you think would go well together—colors you find appealing in combination with each other, whether saturated or unsaturated.

The process is very much an intuitive one, but don't overdo it. You have a better chance of success by restricting the number of colors you use.

It's a lot like going to the paint store and picking out colors for rooms in your home. We don't usually bring a color wheel with us or even think about a color scheme. We do think about the temperature, value and brightness, however, as we play with color combinations. Why not try the same thing for a painting?

Instead of a paint store, you have the colors in your paint box to choose from. Be careful to check them against a color wheel so that they don't fall into the pattern of the traditional schemes.

It's important to mix and experiment with your colors. Try mixing two at a time and fading with water, then three at a time and fading. This will give you an idea of the range of colors you will have to play with.

You will feel as if you are on the edge of exciting new territory with this scheme because you are exploring and manipulating colors without any idea of results or guarantee of success.

INTUITIVE
Colors for an intuitive scheme are chosen because of their personal appeal together. Avoid any traditional pattern, structure or relationship.

INTUITIVE SCHEME TIPS

Don't forget to write down the names of the colors you're mixing because you are bound to find some unusual results and just may want to mix them up again. You will also find that certain color combinations suggest how they can be used. You might even have images flashing across your mind. Pay attention. Make a note for a future painting.

Whatever colors you choose, stick to them and you will achieve color harmony. The results may not always be pretty, but your colors will be harmonious.

Try to have one dark color to help mix other darker colors. Use transparent or semi-transparent colors. Opaque colors run the risk of producing mud in a mixture.

You still need dominance in this color scheme, i.e. a value, a temperature and an intensity (purity) that is most frequently used throughout. You will also need variety within that dominance.

Choosing the Colors for Your Scheme

Sometimes we forget that we have a wide choice of colors no matter what type of scheme we follow, and that the choices we make will directly affect the results of mixing and adjusting that we're going to do.

There is more than one red, yellow and blue. For example, if we choose a primary triad as our scheme, we have many reds, yellows and blues to choose from, as evident in the top part of the chart to the right, and each combination of these three will produce very different mixing results. The same variety of choice in color is true no matter what scheme we use. We mustn't let the simple hues on the color schemes keep us from exploring the wide choice of colors we could use.

But, there is more. In the lower part of this chart are some of the unsaturated primary colors that can also be part of a triad, but we must be careful—many are very opaque and can instantly turn a mixture into mud. You can stay out of trouble by never including more than one other color with an opaque color in a mixture, and by trying to use opaque colors in a watered-down form where their unique beauty can stand out. See the pigment characteristics chart on the next page for help in making your choices.

Unfortunately the only way that you can effectively make use of color schemes is to take the time to experiment with them. Start by choosing colors for five or six primary triad combinations and see what kind of mixing results you get. Don't forget to label the colors you use. You are bound to discover some really unusual colors and combinations, and it would be nice to know later how to do it again.

1. Cerulean Blue
2. Prussian Blue
3. Phthalo Blue
4. Winsor Blue
5. Cobalt Blue
6. Ultramarine Blue
7. Ultramarine Violet
8. Indigo
9. Payne's Gray
10. Quinacridone Gold
11. Aureolin
12. Lemon Yellow
13. Cad. Yellow Light
14. Indian Yellow
15. Cad. Yellow Deep
16. Raw Sienna
17. Yellow Ochre
18. Naples Yellow
19. Raw Umber
20. Burnt Umber
21. Sepia
22. Cad. Red Light
23. Cad. Red Deep
24. Quinacridone Red
25. Winsor Red
26. Permanent Red
27. Alizarin Crimson
28. Permanent Rose
29. Red Rose Deep
30. Quinacridone Rose
31. Magenta
32. Quinacridone Violet
33. Kaput Mortum
34. English Red
35. Venetian Red
36. Quinacridone Burnt Orange
37. Burnt Sienna

CONSIDER ALL THE OPTIONS FOR YOUR TRIAD
Here is a selection of primary colors that can be used for the hues blue, yellow and red. The top part of the chart lists saturated colors while the bottom lists the seldom-considered unsaturated colors that can add a dramatic effect to a primary triad.

STANDARD RELIABLE COLORS LISTED BY PIGMENT CHARACTERISTICS

TRANSPARENT LOW OR NO STAINING

SEMI-OPAQUE TO OPAQUE LOW STAINING

TRANSPARENT TO SEMI-TRANSPARENT LOW STAINING

TRANSPARENT STAINING

KNOW THE CHARACTERISTICS OF THE PIGMENTS YOU'RE USING

Knowing the transparency and staining quality of the paint you are using can affect the results of the technique you may wish to try. For example, if you plan to scrape color back with a palette knife, it would be better to mix a non/low stainer with a stainer. The scrape marks will be the color of the stainer.

*These colors are mixtures that can vary according to the pigments used. When purchasing paints, avoid those with unreliable or undesirable pigments.

1. Viridian, PG18
2. Cobalt Blue, PB28
3. Ultramarine Blue, PB29
4. Permanent Alizarin Crimson, PR209, PR192
5. Quinacridone Red, Roses, Rubys, Magenta, Coral, PR206, PR207, PR202, PR122
6. Quinacridone Violet, PV19
7. Quinacridone Purple, PV55
8. Quinacridone Burnt Orange, PO48
9. Quinacridone Gold, PO48, PY150
10. Green Gold/Azo Green, PY129
11. Quinaridone Sienna, PO49 + PR209
12. Quinacridone Burnt Scarlet, PR206

13. Permenent Red, PR101, PR102*
14. Cadmium Red Light, Medium, Deep, PR108
15. Cadmium Scarlet, *
16. Cadmium Orange, PO20
17. Cadmium Yellow Light, Medium, Deep, PY35, PY37
18. Yellow Ochre, PY42, PY43
19. Venetian, English, Indian Red, PR101
20. Burnt Umber, PBr7
21. Phthalo Yellow Green, Permanent Yellow Green, *
22. Cerulean Blue, PB35, PB36
23. Indigo, *
24. Payne's Gray, *
25. Chrome Oxide Green, *

26. Sepia, *
27. Naples Yellow, *
28. Lemon Yellow, PY3
29. Aureolin, PY40
30. Gamboge (Original, New or Hue), *
31. Raw Sienna, PBr7
32. Burnt Sienna, PBr7
33. Raw Umber, PBr7
34. Sap Green, *
35. Hooker's Green, *
36. Ultramarine Violet, PV15 (better to mix PB29 + PV19)
37. Phthalo Green, PG7
38. Phthalo Blue, PB15
39. Prussian Blue, PB27
40. Thioindigo Violet, PR88 MRS
41. Indian Yellow, *

MUTED COLORS

Left side (top to bottom), COOL FAMILY:
- Phthalo Violet
- Quinacridone Violet
- Ultramarine Violet
- Ultramarine Blue
- Cobalt Blue
- Phthalo Blue/Prussian Blue
- Cerulean Blue
- Phthalo Green/Viridian
- Hooker's Green
- Sap Green

Left side (continued), WARM FAMILY:
- Green Gold/Yellow Green
- Quinacridone Gold
- Hansa/Lemon Yellow
- Cadmium Yellow Light
- Gamboge/Aureolin
- Indian Yellow
- Cad. Yellow Deep
- Cadmium Red Light
- Cadmium Red
- Permanent Alizarin Crimson
- Quinacridone Red
- Permanent Rose/Red Rose Deep

Right side (top to bottom), WARM FAMILY:
- Green Gold/Yellow Green
- Quinacridone Gold
- Hansa/Lemon Yellow
- Cadmium Yellow Light
- Gamboge/Aureolin
- Indian Yellow
- Cadmium Yellow Deep
- Cadmium Orange
- Cadmium Red Light
- Cadmium Red
- Permanent Alizarin Crimson
- Quinacridone Red
- Permanent Rose/Red Rose Deep
- Phthalo Violet
- Quinacridone Violet

Right side (continued), COOL FAMILY:
- Ultramarine Violet
- Ultramarine Blue
- Cobalt Blue
- Phthalo Blue/Prussian Blue
- Cerulean Blue
- Phthalo Green/Viridian
- Hooker's Green
- Sap Green

← COMPLEMENTARY →

INFINITE MUTED COLOR POSSIBILITIES

The problem with a traditional color wheel is that there is not enough room in the middle to show all colors resulting from mixing complementary, split analogous and triad colors.

In my color rectangle, I've arranged opposing spectrums of complementary colors down apposing sides so you can see the mixing results in between. Note: This rectangle is computer generated and as such is only an approximation of watercolor pigments. Paint names are also an approximation and for reference only. The main reason for this chart is to make you aware of the fabulous range of muted colors we can make from those of a color wheel.

38

COLOR TERMS AND ASPECTS OF COLOR THAT YOU NEED TO KNOW

COLOR NOMENCLATURE
Hues: The generic names given to parts of the spectrum or color wheel (examples: red, green, yellow, red-orange)
Colors: Variations in hues; are given trade names that are capitalized (examples: Cobalt Blue, Burnt Sienna)
Pigments: The main colorant materials used to make paints, consisting of a wide variety of plants, animals or minerals and now chemicals.

PAINT PERFORMANCE AND PIGMENT CHARACTERISTICS
These features affect techniques you may wish to use and the physical lifetime (resistance to fading, darkening or color shifting) of your painting.
Permanence: unchanging to fugitive
Transparency: transparent to opaque
Staining ability: staining to non-staining

COLOR CHARACTERISTICS
Hue
Temperature (warm or cool)
Intensity (purity, saturation, brightness)
Value (light or dark)

wine browns — 1 — Phthalo Green

red browns {
2 — Phthalo Green
3 — Phthalo Blue
}

orange browns — 4, 5 — Ultramarine Blue

yellow browns {
6
7
8
9
} Cobalt Blue

1. Kaput Mortum
2. Venetian Red
3. Brown Madder (Quinacridone)
4. Burnt Sienna
5. English Red
6. Raw Sienna
7. Raw Umber
8. Burnt Umber
9. Sepia

UNSATURATED, COMPLEMENTARY COMBOS
It's easy to mix muted colors and grays from unsaturated browns and saturated blues and greens. Since this is computer generated, the mixed results are approximate.

There is a tremendous range in browns, even amongst those with the same generic name. It is best to wash out the color to reveal its true identity.

A GIFT
Sometimes a particular color combination will spark an idea for a painting. Don't ignore it; write it down. Our creative spirit feeds us ideas in many ways.

Center of Interest, Focal Points and Pecking Order

The center of interest is the area of most importance in your picture. The viewer sees it first and spends most of their time exploring it. The focal point is the spot of most importance within the center of interest. For instance, say an old man is sitting on a bench, carving a piece of wood. The whole figure and bench is the center of interest, but his face, hands, piece of wood and knife are focal points.

In my pictures the center of interest varies in size according to the subject. Sometimes I want the viewer to experience a major natural event, in which case it is made large to do it justice. The various focal points within it lead the viewer around the center of interest. The edges of the center of interest are not clearly defined, and the area beyond it contains few distractions.

For example, say I create a picture in which the sun is setting over a wide beach and reflects off the water and crashing waves. The dark beach and far shoreline are in contrast to the bright part of the water and sky. This large area is the center of interest. It is here that I will include all the things I really want you to see, but specifically the water sparkles and dark islands. For now these will be my focal points.

As I move toward the edges of the focal area, there are fewer and fewer things of importance, but there is no hard, defined edge to it. The atmosphere that covers the entire sky and water has been darkened around the outside so that our eye doesn't spend much time there and is enticed back into the lighter, more dramatic area.

However, if we start introducing other objects into the center of interest area, some interesting things start happening. We know that anything that contrasts its setting by being out of place, suggesting movement, more detail, greater size or different color or value, will take visual priority, but it goes beyond that. A visual "pecking order," where we prioritize what we see, also seems to take place.

Let's suppose we introduce a boat. It stands out because of its location The center of interest is the area of most importance in your picture. The viewer sees it first and spends most of their time exploring it. The focal point is the spot of most importance within the center of interest. For instance, say an old man is sitting on a bench, carving a piece of wood. The whole figure and bench is the center of interest, but his face, hands, piece of wood and knife are focal points.

In my pictures the center of interest varies in size according to the subject. Sometimes I want the viewer to experience a major natural event, in which case it is made large to do it justice. The various focal points within it lead the viewer around the center of interest. The edges of the center of interest are not clearly defined, and the area beyond it contains few distractions.

For example, say I create a picture in which the sun is setting over a wide beach and reflects off the water and crashing waves. The dark beach and far shoreline are in contrast to the bright part of the water and sky. This large area is the center of interest. It is here that I will include all the things I really want you to see, but specifically the water sparkles and dark islands. For now these will be my focal points.

The center of interest is large (indicated by the dotted white circle) so the viewer can be entertained with as much interesting detail about this event as possible. The major focal point(s) will be within it.

Not just a boat but an object from a different world is introduced. This will instantly attract the eye.

As I move toward the edges of the focal area, there are fewer and fewer things of importance, but there is no hard, defined edge to it. The atmosphere that covers the entire sky and water has been darkened around the outside so that our eye doesn't spend much time there and is enticed back into the lighter, more dramatic area.

However, if we start introducing other objects into the center of interest area, some interesting things start happening. We know that anything that contrasts its setting by being out of place, suggesting

40

Going further, let's add some birds. Now they stand out as more important because they are a life form and indicate movement as well.

Finally, add an even higher life form, a human, and note where the eye goes. You've also created movement among the focal points within the center of interest.

movement, more detail, greater size or different color or value, will take visual priority, but it goes beyond that. A visual "pecking order," where we prioritize what we see, also seems to take place.

Let's suppose we introduce a boat. It stands out because of its location against the light waves, and its angled mast contrasts the horizon but more importantly it is not of the natural world. It is a human construction and its uniqueness in this setting makes it stand out.

MORE ON PECKING ORDER

Have you noticed, with all things being equal, that a flower usually has more visual appeal than its foliage? A human figure draws more attention than an animal. I am unclear of the reason for this pecking order, but it might say something about our human priorities. Regardless, as you compose your pictures, keep in mind that your focal point should not be upstaged by something of a higher order.

THERE ARE EXCEPTIONS

An object will increase in attractiveness if it suggests movement or has more detail, greater size or greater contrast. A plant with colorful, detailed foliage, for example, may attract more attention than its flower, or a butterfly in flight can attract the eye more than a bird sitting still.

WORDS, SIGNS AND SYMBOLS

Be very careful when adding these elements to a painting. Depending on their size, visibility and location, the powerful attractiveness of words, signs and symbols can supersede everything else. They can be an important element in your picture or a powerful distraction. Learning where to place and how to obscure these features so they suit their role in the picture is important.

A GENERAL PECKING ORDER

From least to most, this is the order in which our eyes are drawn to the following:
- Large scale nature (forests, mountains, water)
- Foliage (well defined)
- Flowers (well defined)
- Insects (butterflies, moths, dragonflies)
- Human-made structures (machines and forms of transportation, roads, bridges, etc.)
- Birds, reptiles, fish, amphibians
- Animals
- People—small (you notice body and head direction)
- People—mid range (you notice body language, head direction)
- People—up close (you notice body language, face direction, eye direction, facial expression)

A Comparison Between Picture Making and a Stage Play

Here's a parallel that may further help you understand how and why the elements and principles of design are important in the construction of a painting.

Aside from the fact that a picture is like a snapshot in time and a stage play is a continually evolving process, they both share some interesting features that we can learn from.

So, what makes a good play? Surprisingly, the same things that make a good picture.

In a play, we have well-developed main characters wrapped in a story that expresses a personal opinion and strong emotions.

In a painting, we have main objects placed in a setting that can also tell a story and evoke strong emotions and express a personal vision, but a painting can also freeze a moment in time.

So, let's continue the comparison and see what we can learn from it.

IN A PLAY...

Q: HOW DO WE KNOW WHO THE MAIN CHARACTER(S) ARE?
A: They get the best lighting, which relegates minor players to the shadows. Good lighting effects depend on making the background appear darker for better contrast.

Lighting is everything.

IN A PAINTING...

Q: HOW DO WE KNOW WHAT THE CENTER OF INTEREST IS?
A: The center of interest gets the good lighting denoted by the strong value contrast. Normally this means that the focal point contains the lightest light and darkest background, but it could also mean that the focal point is the darkest dark with the lightest background (a feat hard to replicate on stage). Things of lesser importance have a lesser degree of contrast.

NIGHT GAMES
11" × 14" (28cm × 36cm)

Artists know that they are only painting what light reveals to them. By varying the degree of brightness, they can focus our attention.

Q: HOW DO THEY MAKE THE MAIN PLAYERS STAND OUT AND LEAD OUR EYE TO THEM?
A: The main characters are well developed. You know more about them than the others, which makes them more interesting to watch and easier for an emotional connection to be made. Their costumes are often unique and more detailed.

The main characters get easy-to-see locations on the set and even though they move around, you can always find them.

The Royal Surveyor is a main character in the play. We can tell.

Q: HOW DO WE MAKE THE CENTER OF INTEREST STAND OUT AND LEAD THE VIEWER'S EYE TO IT?

A: The artist reserves the greatest color, detail and embellishment for the objects of most importance and for areas that will enhance the overall viewing enjoyment without seriously detracting from the center of interest.

Artists locate their center of interest on the paper where it will be most effective but will usually employ several minor points of interest. They also devise ways to subtly and deviously attract and lead the viewer to them. They know that the path will be more interesting if not direct or too obvious.

SPRING CALLING
15" × 22" (38cm × 56cm)

Artists know that, just like a play, it's people—or, in this case, a feathered friend—who attract and focus attention, especially their facial direction and body language.

Q: HOW DOES THE DIRECTOR USE ALL THE PLAYERS TO BETTER CONVEY WHAT IS GOING ON IN THE PLAY?

A: The director pays close attention to the position, costuming, and in particular facial direction and body language for all the players (check out the balloons below for an example).

If the other players are facing the main character, your eye will follow their gaze.

If their gaze is to somewhere else, it will steal the viewer's eye.

Q: WHAT'S THE PICTURE ABOUT AND WHAT DOES THE ARTIST DO TO HELP CONVEY THAT PURPOSE?

A: The artist must also juggle many "players" and in particular, shapes. As seen earlier, we know that animate and inanimate shapes often have direction or seem to "face" a certain way. We can use this "facing" quality to help lead viewers' eyes around the picture and to our center of interest. Artists also know that a wrongly positioned object can impede the flow of the eye throughout the picture.

"Watch where you are pointing that thing."

NOT ALL ART BEGS THE QUESTION

When we ask the question, "What's the picture about?" we are assuming that the artist even considers that important. We should remember that there are many beautiful paintings produced that don't resemble identifiable objects or scenes, are not based on traditional reality and don't want to be pigeonholed. These are pieces that simply celebrate what the medium and a creative spirit can do. However, I am assuming that most people reading this book wish to capture an experience, a personal view or a feeling through the use of recognizable objects.

Q: HOW DO THEY HOLD THE VIEWER'S ATTENTION IN ALL THE RIGHT PLACES DURING THE SHOW?

A: Above all, your attention goes to the one who is speaking, and they are usually the ones who are moving. Stage players know that movement is a powerful attraction. If someone in the background is moving or making a noise, it detracts from the main character. This is called "upstaging" and is greatly frowned upon, especially by the main players.

Also, great effort goes into creating the various sets and coordinating the lighting so that the right mood or atmosphere is created for the scene.

Upstaging destroys the storyline.

Mort and Wilbur are good at making atmosphere.

Q: HOW DO WE HOLD THE VIEWER'S ATTENTION IN ALL THE RIGHT PLACES THROUGHOUT THE PAINTING?

A: OK, paintings may not speak the same way players on a stage do, but they do speak, in a different language—one not for the ears but for the viewer's eyes and subconscious. A painting stirs memories, thoughts and emotions without uttering a sound. The artist cleverly uses colors and lines, shapes and values as tools to resonate and evoke deep feelings that defy words.

The artist must always guard against upstaging their own center of interest with any form of irrelevant distraction, such as excessive detail or even a small but powerful bit of rogue color in an area of little importance.

You're probably also dying to point out that actors have the advantage of getting to move around while a painting just sits there. Physically this is true, but a picture can perform a wee bit of magic: It can lead the viewer's eye from place to place and in and out of a flat two-dimensional piece of paper. It can even make them think that they are seeing movement without so much as a quiver. The artist creates movement by the placement and angling of objects, lines, gradations, perspective and so on, and by using objects as stepping stones for the viewer's eye to follow.

A successful painting is one in which a feeling or mood is created. This feature is read instantly and often subliminally by the viewer and supports the message or subject of the work.

So, the next time you're composing a picture, "Go break a leg."

COBBLE RAYS
14" x 22" (36cm x 56cm)

How does the artist evoke the feeling of serenity? By creating a balance between light and dark shapes, soft and hard edges, but mainly through mingling and blending warm and cool colors into an ethereal, moody atmosphere.

Bottom Line: What Feels Right?

If I gave you a blank piece of paper and asked you to put a circle of any size on it where you think it would look best, you could do it.

If I then asked you to study your paper and put two more circles of any size you want on your paper wherever you think they would look best, you could do it.

If I then asked you to look at your circles and add a straight line from one side of the paper to another in whatever location looks best, you could also do it.

Finally, for something of interest, if I asked you to add a small triangle wherever you think it would look best, you could do it.

If a thousand people did this exercise, they would all be right because there is no wrong. You have arranged your circles and line and triangle the way they would look right to you. You have composed intuitively.

You let your gut feeling tell you where things would seem to look best to you. End of story, except if you were to do this again a thousand times, you would probably do it a thousand different ways, and each would be right.

What you need to do now is transfer that intuitive confidence in composing to picture making by always asking yourself when arranging things, "What *feels* right?" Mind you, you will probably get more than one intuitive answer and have to choose which excites you the most.

EVENING FLOOR SHOW
15" × 22" (38cm × 56cm)

Nature is famous for its impromptu floor shows. This one started at about ten o'clock. This painting is an example of two light directions, from in front of the viewer and from behind them.

THANKSGIVING BOUQUET
19" × 22" (48cm × 56cm)

This bouquet gathered in the wild graced our Thanksgiving table while we camped amid the splendor of the season.

3 Gradations and Reversals

We mustn't forget that the painting process is just a way for you to exercise your creative potential. This means finding great pleasure in inventing and refining new ways of interpreting your world. This chapter could well provide your potential with some new avenues to explore with respect to the creative arrangement of values in your paintings.

AUTUMN PASSAGE
11" × 19" (28cm × 48cm)

Adjusting Values for a Better Picture

When planning the value arrangement for our pictures, we must always be ready to adjust them in order to better see our subject. This means using value contrasts that the picture needs rather than what really exists. Quite frequently values appear as some form of gradation.

A *gradation* is a gradual transition from one condition into another, as when a dark cool color gradually changes into a light warm color.

A *reversal* is when one condition changes immediately into its opposite, as when switching from positive painting (painting shapes) into negative painting (painting the area that surrounds those shapes).

Gradations in all forms are one of the most appealing features in a painting. We use them all the time in virtually every picture but we seldom take full advantage of them, especially by placing opposing gradations next to each other. This produces a wide range of contrasts and a wonderful opportunity to work negative painting into your picture.

Another way we seldom use gradations is as a major way of composing part or all of our picture.

Too bad.

We are missing a chance to inject some real freshness and much-needed contrast into our work.

When sketching from nature or photos, never take the actual value arrangement as sacred. Think of it as a suggestion, because in a few hours it will have all changed anyway.

CREATING CONTRAST WITH VALUES
In the first sketch is a simple arrangement of tree trunks. The second sketch has had gradations of value applied so as to create contrast between the various trunks and their background. You will soon discover that if you get the values arranged so they contrast each other, you will also be establishing the light direction.

This is only one way to do it. Copy the first sketch and try your own arrangement.

You can create contrasts by locating gradations/transitions opposite to each other. The greatest reversal contrasts are at the extremes.

A gradation can occur smoothly or in steps, as shown in this turquoise-into-brown example. It automatically creates a gentle movement back and forth in the direction of change.

A color alone can grade into a form that is darker, lighter, of different temperature, of different purity, or a completely different hue.

Putting Gradations and Reversals to Work

Look at the finished painting on the next page.

This was developed from the field sketch shown on this page using a gradation model (1B) where the criteria is to use horizontal bands of varying sizes graded horizontally in values that oppose each other, and that's all. The steps are shown.

You will notice no mention of subject or color or locale or season. In other words, if you were to develop a picture from this same criteria using your own photos, sketches or imagination, your options and the possibilities would be endless.

Your objective is to first examine the criteria from each of the models that follow and, with sketchbook in hand (and a few photos or sketches), start exploring the ideas for painting that the criteria suggests. There are no restrictions. Let your imagination surprise you, and it's OK to deviate slightly from the model. Once you understand the criteria and start sketching, the ideas will start coming. Don't be satisfied with the first idea; the best usually comes later on.

FIELD SKETCH
I made the sketch while out fishing. Fishing is a good excuse to get out sketching, and vice versa.

MODELS 1A AND 1B
The criteria for these models is irregular horizontal or diagonal bands of various lengths and widths with contrasting gradations along their length. For the demo below, we'll create a composition featuring opposing horizontally graded bands of color, based upon model 1B (left).

1. Start at the top, dark to light
For the sky, I painted a wash of color that's graded horizontally from dark to light across the top of the paper. You will notice that I didn't say what color to use; I believe you are old enough to choose whatever colors you like. Besides, it's not the specific colors that matter but rather their value, and possibly their temperature.

2. Add trees graded oppositely
The first hill is a band graded from dark to light in the opposite direction for contrast to the sky. The top edge of the dark end defines some positive trees, while the bottom of the area creates negative treetops for the next row of trees.

48

3. Create more positive and negative trees
The second band of trees is darkest and cool against the light hills on the left and grades to the right, where it defines the bottom of the light negative trees with light warm color.

4. Add the water and suggest grasses
The water is graded from dark on the right to light on the left. The bottom of this area defines some possible light grasses. While wet, some color is lifted with a damp brush to suggest reflections on the water.

5. Make changes when you need to
In order to maintain contrast with the background, I chose not to reverse the direction of the gradation in this portion of the painting (the grassy land). This is an example of how you can deviate from the criteria when the picture needs it.

6. Boost the contrast
Finally, the addition of very dark evergreens that meld into the dark grass increase the contrast with the light background and better define in the negative the light grasses in the middle ground and foreground. The criteria of contrasting horizontal gradations have been achieved.

DON'T FORGET A CENTER OF INTEREST . . .

. . . i.e., something that stands out because of its location and/or contrast to its background. Let your instincts tell you where it should be.

MODEL 2A
Criteria: Irregular horizontal or diagonal bands individually graded vertically from dark to light.

1. Lay in the hills
The lakes in this picture are first saved with packing tape. The hills are then graded from warm green (Green Gold) to pale blue (Cobalt Blue).

2. Work from dark to light, warm to cool
All of these hills have dark bottoms (valleys) and light tops. Cobalt Blue, Green Gold and Indigo are used throughout. Four hills that do not touch are painted first. As you move into the distance, the colors you use should become lighter and cooler. While the paint is still moist on each hill, the texture of trees was produced by daubing the end of a moist, flat bristle brush vertically into the paint, for instant forests.

3. Paint more hills and the water and sky
The remaining hills are added, each dark at the bottom and fading to light at the top. The packing tape is removed and the lakes given a blue wave pattern of your choice. The same blue is then drybrushed in the sky for clouds. Before this paint dries, a damp brush is used to soften some of the edges of those drybrushed clouds. When dry, the most distant hill is painted a solid mauve to better contrast the sky and hill in front of it.

4. Selectively add cast shadows
Since you have clouds, you will also have shadows on the hills. These marks, a mixture of Cobalt Blue and Indigo, cover the selected hills from top to bottom and are faded on the ends. Don't get carried away and add too many.

For variety, try painting this scene in a different season.

MODEL 2B
Criteria: Irregular horizontal or diagonal bands individually graded vertically from dark to light (in the opposite direction as 2A).

1. Start the same way
These hills are the reverse of the previous ones but they start the same way, with the masking of the lakes and a graded warm to cool wash from front to back.

2. Make tops dark, fading lighter downward
These hills are graded from dark at the top to light in the valleys. Start with a concentrated dark warm mixture along the top of the ridge and fade downward. Again, Cobalt Blue, Green Gold and Indigo are used throughout. Color mixtures become cooler and paler in the distance. As before, use a moist, flat bristle brush to create a "tree" pattern in the damp paint. Start with hills that are not touching.

3. Add the cooler hills and the water and sky
Paint the remaining hills and suggest clouds in the sky by drybrushing with pale Cobalt Blue. When dry, paint the furthest hill in mauve. Remove the packing tape and paint in the lakes with Cobalt Blue that is made darker near the far shores to suggest land shadow.

4. Selectively add cast shadows
Because you have clouds, you will also need shadows on the hills. A mixture of Indigo and Cobalt Blue that covers a few areas will suffice. Fade out the edges of your shadows.

Try this scene in a different season for variety.

MODEL 3A
Criteria: Random vertical shapes graded vertically in opposition to the background. Upper and lower masses may be present (such as trees, vegetation, flowers, people, columns, etc.).

1. Save the trees and water sparkles
Because these trees will be backlit, there needs to be a light source (sparkles on water) that is saved with masking fluid (applied with the handle end of a small brush). Because there will be a reversal of values, the birch trees and some leaves will also need to be saved—in this case, with packing tape and masking fluid.

2. Lay in warm color from dark to light
A loose gradation of warm color is laid in from dark at the bottom to light at the top. While damp, give this a loose spray of water for a mottled effect. Quinacridone Violet, Quinacridone Burnt Orange and Indian Yellow were used for this passage.

3. Paint graded, mottled trees
The packing tape and masking fluid are removed. Each tree is graded from very dark at the top to light at the bottom. Slight blotting with a rolled paper towel helps give a mottled effect in the grading.

4. Reveal the backlit effect and add details
Remove the masking from the water. You should be able to see the backlit effect. To create the illusion of birch bark, lay on some short drybrush marks (Indigo, Quinacridone Burnt Orange) with a ¾-inch (19mm) flat hog bristle brush. Try to follow the contour of the tree trunk. While still wet, pull off some of the edges of these marks with a damp brush. Lay in dark branches with a palette knife or rigger brush. Paint some darker leaves (a mix of Quinacridone Violet and Quinacridone Burnt Orange), especially near the top, and finally color the light leaves.

MODEL 3B
Criteria: Random vertical shapes graded vertically opposite to the background (in the reverse manner as 3A). Upper and lower masses may be present.

THIN IT OUT

Thick masking fluid makes it hard to save precise shapes. Most masking fluids can be thinned with a tiny amount of water and still do the job.

1. Apply masking
Because there will be contrasting gradations in this front-lit picture, we start by masking out our birch trees and leaves with packing tape and masking fluid applied with a flat stick that has had one end squared off and beveled like a chisel.

2. Paint cool and dark to warm and light
Grade a passage of color (Phthalo Green, Cobalt Blue, Green Gold from cool dark green at the top to warm pale green at the bottom. Being a passage it only needs to suggest something—in this case, the edge of a forest.

3. Paint the birches
Grade the birches from dark at the bottom to light at the top. To create the illusion of birch bark, lay on some short drybrush marks (Indigo, Quinacridone Burnt Orange) with a ¾-inch (19mm) flat hog bristle brush, following the contour of the tree trunk. While still wet, pull off some of the edges of these marks with a damp brush.

4. Develop more texture and details
Add more texture and marks to the bark if needed. When dry add very dark branches (Indigo, Quinacridone Burnt Orange) with a palette knife or script brush. Finally, add darker leaves in the foreground and color the pale leaves in the background.

5. Add shadows
Cast shadows confirm that the trees are front lit. Apply dark and medium-value color (a mix of Cobalt Blue and Indigo) with a ¾-inch (19mm) to 1-inch (25mm) flat synthetic brush. Follow the curved contour of the trunks as you move quickly and spontaneously. Also add some shadow to one side of the trunks.

53

MODELS 4A AND 4B
Criteria: A central mass with supports and base is graded from light to dark vertically against a background graded in the opposite direction. (Model 4B [right] is shown in the demo.)

1. Establish the first treetops
On a dry, dulled Cobalt Blue sky, a darker silhouette of treetops is graded downward through pale Quinacridone Red and Quinacridone Gold to clear. The reverse comes up from the bottom.

2. Add more trees, getting warmer
Successive rows of treetops that are darker on top and around the edges are added. The color gets gradually warmer (Quinacridone Red and Quinacridone Gold).

3. Form trunks by painting the space around them
Tree trunks seen at the edge of the forest are painted in the negative.

4. Go darker to develop more trunks
Tree trunks farther back in the forest and some higher branches are captured with further negative painting, by using even darker color.

5. Paint water reflections and grasses
Reflections in the water are created by first painting the whole area with some of the light foliage color. When this dries to damp, some darker color from between the trunks above is applied to approximate the gaps between the tree trunks. A small damp brush can further lift off color to help fine-tune the trunk shapes. Foreground grasses are created by making long overlapping strokes with the sharp edge of a flat synthetic brush, using leftover colors from the foliage and reflection above.

Here is another painting based on the reverse criteria.

54

MODEL 5A: BASIC POSITIVE PAINTING
Criteria: Overlapping positive shapes that get lighter as you move into the picture space to produce a backlit effect or foggy/hazy atmosphere.

STEP BY STEP

As illustrated in these examples, gradations can occur in steps as opposed to a smooth transition. When these gradations (light to dark, dark to light) are combined, a reversal of positive and negative shapes occurs which causes the viewer's eye to move in, out and around the picture space.

1. Start dark, with plenty of space
The first layer of trees is dark. Leave room for those to follow.

2. Go lighter with the next layer
A second row is paler and appears farther away.

3. Save the lightest for last
A third even paler layer takes us well into the distance or fog.

MODEL 5B: BASIC NEGATIVE PAINTING
Criteria: Overlapping negative shapes that get darker as you move into the picture space. These shapes produce a front-lit effect.

1. Paint around the lightest first
A few trees are defined by painting the space around them a medium-value color.

2. Define the next row with a darker layer
A second row of trees is created by painting around them and the ones already defined in the first row.

3. Apply the darkest color
A final row of distant trees is defined along with the first two rows by a very dark color.

MODELS 6A AND 6B
Criteria: Irregular horizontal or vertical bands of color graded in steps from light to dark, or dark to light, from the center out. (We'll use 6A [left] in the demo.)

REFERENCE PHOTO
The photo is just a suggestion, a starting point, a seed of an idea. Don't expect to find the perfect composition; it's your job and challenge to create it.

1. Make the first layer, creating clouds
My objective was to capture the ominous feeling of the storm clouds. My first layer of color (Cobalt Blue) is mottled and defines in the negative some clouds in the foreground.

2. Add a darker layer
A second layer of slightly darker mottled color defines clouds in the middle ground.

3. Go darker, defining more clouds
Another layer of darker color defines even more clouds farther back.

4. End with more darks, definition and drama
The fourth layer of clouds is the darkest, with Indigo being added to the blue to darken it. Additional small billows are added to the previous layers of clouds using pale Cobalt Blue and fading outward. The airplane, painted with acrylic paint, was added for drama.

Having Positive and Negative Work Together

As you know by now, a positive shape is one that is nameable or recognizable (a cat, a cloud, a tree, etc.), and negative space is the area around a positive shape, and it can be lighter or darker than the positive shape.

In watercolors if we want something to be dark, we paint it so, but if we want it to be light, we must either mask it out or learn to paint around it with a darker color. This process of painting around something—"painting in the negative"—has driven more than a few very nice people a wee bit crazy.

Perhaps if they think of it as merely painting the background of a subject in a darker color, it would help. And the world will not come to an end if they also start by sketching the outline of the subject to be saved. Where things tend to fall apart is when this process is repeated in the background in order to make more shapes stand out by painting an even darker background (see next page).

To add a decidedly fresh and distinctively loose watercolor quality to your work, always look for opportunities to switch back and forth between positive and negative painting. It will invariably involve shapes that are positive along one edge and negative along the other.

SPRING FLYERS (FIELD DEMO, FRANCE)
11" × 14" (28cm × 36cm)

WORKING TOGETHER
The feeling of light and space is enhanced in both of these paintings by having some of the flowers painted in the positive and some in the negative.

FORSYTHIA (FIELD STUDY)
14" × 11" (36cm × 28cm)

STEP BY STEP: REVERSAL OF POSITIVE AND NEGATIVE PAINTING

Let's practice the process of switching between these two ways of painting. First, we'll try a negative-to-positive forest.

1. Start painting in the negative
Start by painting a few trees in the negative on one side of your paper.

When you come to defining the right side of the last tree with negative painting, you can start a reversal to positive painting by painting the right side of that mark as positive leaves. This is an example of a shape being negative on one side and positive on the other. Paint that mark slightly darker than the other negative shapes.

2. Define negative and positive leaves
Continue painting this shape across the top and bottom of the scene. The top edge of the upper mark defines light leaves in the negative. The bottom edge defines positive dark leaves. At the bottom of the scene, the shape defines positive ground plants on one side and negative grass on the other.

3. Add positive trunks and branches
When you add two to three positive tree trunks and branches, you are better able to see the positive forest.

4. Add darks for depth
Now create depth by painting darker negative shapes on the left side and lighter positive shapes on the right. Repeat this for greater depth. You will notice that this produces a gradation of values that takes us in and out of the picture space. Adding cast shadows on the tree trunks or, if you wish, scrubbing off some small sun spots on the darker middle-ground trees, will add to that illusion.

STEP BY STEP: ANOTHER TAKE

There are many variations on this procedure for you to explore. Try a negative to positive to negative layout or a positive to negative to positive.

In the following picture I wanted to use positive and negative painting to capture the early morning light on three major trees.

1. Define the negative while painting the positive
To start I gave my paper a soft wash of pale warm and cool grays (Cobalt Blue, Raw Sienna). When this was dry, I used Cobalt Blue, Burnt Sienna and a touch of Green Gold to paint the positive shapes for the overhead foliage, the evergreens on the right and the point of land on the left. In doing so I was also defining in the negative the upper portion of the major tree trunks, the rocks on the lower right and the smaller tree trunks in the distance.

2. Build greater contrasts
This painting is about creating positive and negative contrasts. At this stage a more concentrated version of the same three colors from step 1 was sponged on to create greater contrast with the top of the trunks while another row of evergreens more clearly defines the rocks on the right. Some paler gray trees were added to better define the middle section of the tree trunks. A portage sign was masked out (with masking tape) on the nearest tree.

3. Just add water, and a bit more contrast
If there's a portage nearby, I had better add some water. By painting the area above and behind the masked sign with a pale warm gray, I was able to create the illusion of a distant shoreline. I also added some green ground cover and darkened the background ridge, all to increase contrasts. When this was dry I gave the foreground rock and large tree trunks a soft warm glaze (Cadmium Red Light, Indian Yellow).

4. Create a sense of light using cast shadows
The final stage to creating a sense of dappled sunlight was to add dark cast shadows (Cobalt Blue, Indigo) to the rocks and tree trunks. These were laid on quickly with ¾-inch (19mm) and 1-inch (25mm) flat synthetic brushes. Tape was removed and the portage sign painted yellow. When dry, a figure was added with a fine, lightproof pen.

4 Mingling Colors and Passages

I did not paint foliage in the painting you see on this page. I painted a mass of warm colors over a large portion of the paper, but because I put in tree trunks and branches, you think you are seeing trees. That's how mingling colors and passages work to save you time by letting the viewer use their imagination. As you'll see, passages often involve mingled colors.

OCTOBER CELEBRATION
15" × 22" (38cm × 56cm)

Mingling Colors: Getting More Excitement From Your Pigments

Mingling is when colors *physically* flow together because of their wetness or *visually* flow together because of a similarity in value, temperature or intensity. In either case, mingled colors tend to be more appealing when they fill an area as opposed to filling it with a single solid color.

When physically mingling, some of the original colors should remain visible. You will also have what they produce by partially mixing. The mixing can occur either when the paint is wet or, taking advantage of watercolor's transparency, when new strokes partially cover existing dry paint.

The total effect you get depends on how and when you apply the paint (and water) to the paper and the technique you may use.

PREPARING THE PAPER
The area in which you do your mingling could be dry, wet or partially wet. You can make it partially wet with a coarse spray from an adjustable spray bottle (not a mister), spattering with your fingers, sponging, or drybrushing with a large flat bristle brush.

APPLYING PAINT TO PAPER
Brushes in various sizes are the obvious tool to deliver paint to your paper, but occasionally consider a sponge, eye dropper, stick, the edge of a palette knife, or any combination of these.

The following pages show various mingling techniques and explain how to do them.

WET IN WET
One of the easiest ways to mingle colors is to wet the paper first and then add two to three colors, one at a time, by daubing with a brush, spattering, sponging, etc. Do not overmix. Make sure some of each original color remains.

WET ON DAMP
Another easy way is to start with a layer of one color and then, while this is still damp, drop, spatter or stroke other colors into it. When the paper dries back to damp again, more color can be added. As more and more color or water is daubed on, the result becomes a distinct pattern with contrasting lines and values. This is unlike the soft effect of the wet-in-wet mingling. Caution: The results can be distracting unless you want the attention.

DROPPING COLOR ON A GRADED WASH
A variation is to lay down the initial wash as a gradation between two colors and then add a third color by dropping, spattering, etc.

WET ON DRY
If working on dry paper, you will need to lay down your colors quickly with broad brushstrokes (see the first tip in the sidebar). The colors will blend together where the strokes overlap, but be careful not to destroy all the individual colors by overworking them. You may also want to save white areas.

It is important to have your paint mixed in pools beforehand. As you switch between colors, don't bother cleaning your brush. You'll just waste time and paint. When you are finished, you will have a wet, multicolored wash.

MINGLING TIPS

- Be consistently random with your brushstrokes. To avoid a "windshield wiper" effect, pick a different direction for each stroke.

- Be ready. Have the colors you plan to use mixed in pools on your palette before you start. Nothing interrupts the journey like running out of gas.

- Write down the names of the colors you use. You will forget.

- You will get the best results using transparent or semi-transparent colors. Opaque colors will slow the mixing of pigments and often muddy the results.

SPATTERING
Mingling can also be done by spattering colors. This can be done all at once or as layers dry. Spattering can be done with a toothbrush and palette knife or by striking a loaded brush against another.

WITH TOOTHBRUSH AND PALETTE KNIFE
Keep the palette knife as horizontal as possible to prevent excess paint from dripping off the knife when spattering.

BRUSH AGAINST BRUSH
Warning: There will be kick-back spray in the opposite direction when you spatter this way.

COLOR CONSIDERATIONS

You can mingle whatever colors you want, but if you intentionally choose them for their value, temperature and intensity (purity/saturation), you can get some very effective results.

Basically, the more your colors are similar in terms of these characteristics, the more easily they will mingle visually, and the resulting colors when mixed physically will be clean and bright.

When you use colors that are increasingly different from each other in terms of value, temperature and intensity, visual blending ends and physical blending produces an intriguing pattern with more contrasts and dulled colors.

MINGLING SIMILAR COLORS
Visual mixing occurs when colors of similar value, temperature and intensity are used.

TRANSPARENT COLORS MINGLE BETTER

The transparency of your colors affects mingling. The more opaque a color is, the less effective it is for mingling.

MINGLING DISSIMILAR COLORS
Mingling colors of different value, temperature and intensity creates a random pattern and various dulled colors.

A SIMPLE VISUAL MIXING TEST
A good way to see how colors mingle visually is with house paint chip cards. Randomly pick a few color sample cards and watch what happens when you overlap two cards and slide them up and down. (Hint: It helps if you squint.) Quite frequently two colors, when they meet, will want to blend with each other because they are of similar values. That's how effective mingling works.

MINGLING PURE AND DULLED VERSIONS OF THE SAME COLOR
If one color is pure and the other a dulled version of it, the result is a powerful, subtle contrast where the pure color adds richness.

MINGLING PURE AND COOL COLORS
If all colors are pure and cool, you create a feeling of clean freshness.

WARM AND UNSATURATED MEETS COOL AND PURE
Warm, unsaturated color (Burnt Sienna) will contrast with cool, pure color (Phthalo Blue) and create some dark grays.

WARM AND UNSATURATED MEETS WARM AND PURE
Warm, unsaturated color (Burnt Sienna) and a pure warm color (Quinacridone Violet) will easily mingle and make the pure color glow.

IN SUMMARY...

Colors can mingle:
1. **Physically** (The degree of wetness of the paper is important.)
2. **Visually** (The more colors are alike in terms of temperature, value and intensity, the more they merge with each other. The more colors are different from each other, the more they will dull one another if mixed and produce contrasts if set beside each other.)

The next part of this chapter will give you ample opportunity to mingle colors.

READY TO MINGLE?
Don't be afraid to mingle colors.

Passages: Paint Less, Say More

A passage is any loose, free-flowing area that implies what could be there without you having to paint it. By definition, a passage is just a "portion" of your painting, but in practice it can become a very magical portion.

This wonderful time-saver has an important effect on the atmosphere and visual impact of your picture, but more importantly it helps imply a spontaneity and mystery so characteristic of watercolors.

Because passages tend to be soft, they don't distract the way hard-edged detail does. They are felt more than seen as the eye senses the feeling they create as it moves through them.

Passages come in all shapes and sizes. Sometimes they cover the entire paper, other times only a portion, such as a foreground, the sky or side of a building.

Chances are that you have already used passages in your paintings but not realized their full potential.

Strangely enough they are usually meaningless on their own but suddenly take on significance when only a small amount of realistic detail is added to suggest a subject.

They are an excellent opportunity to try out more expressive, more imaginative, color schemes.

They might be the initial allover coverage from which images are plucked with negative painting or a background on which images are superimposed with positive painting.

Passages do not eliminate the need for some forethought as to where and when they are applied and how they will be used. You may want to mask areas before you start or mask areas at some stage in the painting.

Smaller passages are used more for implying detail than creating atmosphere. For example, you may use a passage to imply ground cover in the foreground of a picture or a stone wall in another.

Pre-wet only the area involved. You may have to protect the remainder of the painting while you add water and paint.

Following are examples of how passages work in different paintings.

FINDING HOME
11" × 14" (28cm × 36cm)

THE POWER OF SUGGESTION
Large evergreens were suggested over a concentric mingling of Cobalt Blue, Indian Yellow and Red Rose Deep while the paint was still damp. Table salt was then sprinkled onto the paper. When the paint was dry, a positive boat and figure were superimposed and blended into the background. When dry, first brush off the salt and then scrub off the lights using a small, stiff scrub brush.

OCTOBER RECALL
11" × 15" (28cm × 38cm)

A LITTLE GOES A LONG WAY
When the allover vertical passage of Quinacridone Burnt Orange, Cobalt Blue, Permanent Rose and Indian Yellow was dry, a minimal amount of positive and negative painting in the same colors created the illusion of an autumn roadway as one would remember it.

GALAMUS GORGE WALK, FRANCE (FIELD STUDY)
14" × 11" (36cm × 28cm)

A POWERFUL PASSAGE OF NATURAL ROCK
The rock in this gorge is limestone, and so the lower two-thirds of this painting is a pale passage of Cobalt Blue, Burnt Sienna and Red Rose Deep. Negative painting helped imply the crags when it was dry. The top was painted in the positive, with the dark rock added as counterpoint to the deep gorge.

OCTOBER GLOW
15" × 22" (38cm × 56cm)

MINIMAL BRUSHWORK, MAXIMUM IMPACT
What a time-saver! A small amount of negative painting on a passage of mingled yellow, orange and pink creates a whole hillside in autumn splendor while a smaller passage to the lower left creates the illusion of dead grasses, without me having to paint a single blade.

SELECT THE RIGHT SPRAYER

Since a sprayer is frequently used to create passages, it's important that you get one that can produce a coarse spray. Small "mister" sprayers just don't work, so before you mess up your next passage, get one that is adjustable. Empty spray bottles can be found in the gardening or travel container sections in many stores if you can't rescue one from the recycle bin.

EVENING BLISS
11" × 11" (28cm × 28cm)

DIRECTING THE EYE WITH PASSAGES
Here two separate passages take care of the sky and foreground, leaving our eyes to focus on the buildings.

LEAVE A LITTLE TO THE IMAGINATION

When you have an empty area in a composition, try to resist the urge to fill it with some "thing." Invariably it will take away from your composition and possibly upstage your center of interest. It's better to fill that area with a passage of mingled colors that will engage the viewer by making them use their imagination.

Superimposing Positive Shapes on a Passage

Any positive image that is superimposed on a dry passage can be made to appear as if it is merging with the passage by the way we treat the edges of the positive shape.

STEP BY STEP: SNOW SQUALLS
Painting snow squalls is much the same as painting fog because it's what you don't paint that creates the illusion.

1. A juicy start for the sky
The beauty of passages is that no two turn out the same. I produced this one by putting a big juicy puddle of Ultramarine Blue and Indigo on the upper part of my paper and then spraying the edges of it and tilting the paper to get it moving. I lifted a light diagonal shaft with a damp brush, and then, when damp, gave a light spray of water for light spots. You can expect yours to look different.

2. Add a warm hill and suggest some trees
For the land, I chose Phthalo Violet and Indigo not because they are tree colors, but because they add a touch of warmth to this cold day. The concentrated color was applied along the top of the hill with a well-loaded flat hog bristle brush. It was immediately faded downward with another large, damp hog bristle brush that was dragged along the edge of the paint (see pages 75 and 76 of chapter 5 for more on making fog). Trees were scraped in with a palette knife.

3. Suggest a lake and add tree detail
The illusion of a lake and ice is created by dropping color into a lacy pattern of water. The pattern is made by quickly dragging a wet flat hog bristle brush horizontally across the paper and then immediately dropping dark color into this wet area with a well-loaded flat synthetic brush. When the paint hits the wet spots, it flows out. Some areas remain dry. Soften the edges of the water area with a damp brush. Add more branches to the trees.

Using Masking to Define a Passage, Then Positive and Negative Painting for Detail

Sometimes the pattern within a passage serves as the detail for the surface. All that is needed is to define the shapes with positive and negative painting.

STEP BY STEP: ETRUSCAN WALL
One of the intriguing things about ancient buildings is the evidence of earlier architectural modifications that are revealed as the stucco falls off.

1. Apply masking and drop colors wet in wet
I use several photos as reference to create my own arrangement of bricks and stones. I mask out the bars on a window and broken stucco using packing tape. My colors are chosen to express what I think was the warm, earthy splendor of this ancient culture, and I have those colors, which happen to be a triad of Cobalt Blue, Quinacridone Red and Raw Sienna, mixed in puddles beforehand.

I wet the paper and as I lay my paint down, I try to create soft patterns that I can use to suggest bricks and stones in that wall. This is done by dropping one color into another. As the colors dry to damp, I drop in water to create blossoms or use a damp brush to lift color. At this point I decided to make this a twilight setting, and so I used Raw Sienna for the window.

2. Add a bit of definition, but not too much
A light-to-medium value grayish wine color is used to define just some of the cracks between the stones. I wanted just enough to betray a bygone history, to make people wonder, "Which feature came first? Who walked through those arches? What was behind the wall? Who's behind the bars now?"

3. Fine-tune the lights and darks
Masking is removed. Shadow is applied under the edge of the stucco. The inside faces of the bricks around the window are lightened by removing paint with a small scrub brush. When this is dry, the area inside the room that is next to the light bricks is darkened. The bars are now painted, as is the bird. Finally, a glaze of Cobalt Blue applied over everything except the window opening produces a "twilight" effect.

Using Outlines and Value Differences to Define a Subject

Sometimes the background colors are also the main subject's colors. All that defines the subject is an outline and an increase of value contrasts between the subject and its background.

STEP BY STEP: FOREST FIGURE
My intent is to capture the closeness of this forest dweller with the surrounding environment.

1. Lay a mottled wash over a drawing
A light drawing of a figure is made on the paper and a small butterfly is masked out with packing tape. Cobalt Blue, Permanent Rose and Quinacridone Burnt Orange are mingled on wet paper to create an allover mottled wash that will serve as a background and later as the figure itself. While still damp, the paint is given a loose spray of water to help create the mottled effect.

2. Add some details and suggest others
The figure is first outlined with a permanent lightfast pen. It is further enhanced with slightly darker negative painting outside it (under the arm, outside the hips and head) and inside it (under the chin, hairline and middle of the back). The suggestion of foliage is added in the positive that will embrace the figure. Body ornamentation is added. Masking is then removed from the butterfly, and color that is from the same group but slightly different from the dominant cast is added.

Using the Ethereal Nature of Passages with Minimal Masking and Detail

One of the most powerful aspects of a passage is its ability to create a powerful atmosphere. Here, details are not important. Mood and feeling are everything.

STEP BY STEP: MAGICAL MOONLIT VILLAGE
The passage here acts as a magical night veil shrouding a hilltop village.

1. Mask the roofs and the moon
This painting is a bit of an optical illusion. To create the impression of a fictitious hilltop village in moonlight, I mask out only the roofs. I am helped by the fact that so many of the roofs in older villages, especially in Europe, seem to have the same angle. All I needed to do was make random parallelogram and rhomboid-type shapes with the same angle. I sketched them on my paper beforehand, covered them with packing tape, and then carefully cut them out with a very sharp craft knife. I also cut around a dime to add a moon for a light source. Press all pieces of tape down well before painting.

2. Leave lights among a loose passage
A loose, flowing passage of Ultramarine Blue and Indigo, which includes light patches, serves as a sky and atmosphere for the whole painting. Some blotting with a rolled paper towel adds light to the edges of a few clouds. I lifted a light patch at the base of the hill before the paint dried and dropped in a pale Raw Sienna. This will be the lights from "downtown."

3. Suggest buildings (closeup)
The buildings are created by painting vertical strokes of pale gray down from the corners of the rooftops. Most will blend together. When these dry, add a few darker strokes to make some buildings stand out from the others. At the bottom of the village, two rows of buildings along a street are created by painting one in the negative and one in the positive.

4. Work on the roofs and windows
The packing tape roofs are removed to reveal my village in the moonlight. The roofs are given a light touch of Raw Sienna and Burnt Sienna to help warm the picture. The windows are painted in dark gray, or lighter ones are scratched out with a craft knife.

5. Add buildings for balance
To better balance the composition, I added a few more dark buildings on the right side.

5 Atmospherics

Atmospheric conditions are a wonderful way to add mood and mystery to your work. For some reason we are attracted to scenarios where the view is somehow obscured.

SPRING MORN
14" × 22" (36cm × 56cm)

Painting Fog, Haze, Mist, Snow, Dust and Other Forms of Visual Ambiguity

Oil and acrylic painters must paint fog if they want it, and it takes a lot of effort to get it just right. Watercolorists simply imply it by what they don't paint. In watercolors, the viewer reads the lack of paint as atmospherics. Think of the paint we save.

CONDITIONS FOR THE GRAND ILLUSION

Creating the illusion of fog or haze demands that you be aware of the wetness of your paper and paint at all times because this effect is created primarily by letting water move the paint. I prefer this method over lifting paint because it looks more natural, but there are exceptions as we will see later.

GETTING PAINT TO MOVE

There are two basic ways to have water move wet paint on your paper.

The first is to wet the area you want the paint to flow into, followed by daubing a good charge of color along the edge of that wetted area. When the wet paint hits this wet area, it will flow out into it. It does so because the water you put down first immediately started going into the paper and therefore became less wet than the charge of color you then applied. Tilting the paper slightly may help give direction to the fog but is not usually necessary. The hard-edge side of the daubed marks can be developed into trees, buildings, plants, etc. before the paint dries.

The second method requires that you work with two brushes in hand: one that's damp and the other to carry paint. This time you put a good charge of color onto the paper with one brush and then immediately run another larger damp brush along its edge. When the dampness touches the paint, the paint is enticed to flow out into it.

Depending on the wetness of the paint and the dampness of the brush, you may have to repeat this stroke until the paint starts flowing out into the damp area. When it does, make your strokes farther out so that the paint can fade out without a line. Natural bristle brushes, such as hog bristle, are best for this because they release their moisture evenly. This method may seem more difficult, but it gives you more control over where the paint flows. This method can also be used throughout your whole painting wherever an edge needs softening.

METHOD 1: APPLY WATER FIRST, THEN PAINT
Here, a wet patch on the paper sucks the paint off a well-loaded brush. You need only daub it along the water's edge and the color will flow.

METHOD 2: APPLY PAINT FIRST, THEN WATER
Here a large damp brush follows the contour of a freshly painted area. Make sure that you just tickle the edge of the paint in order for it to flow out.

TRY IT OUT

I strongly suggest that you practice these two methods of moving color with water on the back of old pictures before you commit to a full painting.

CHOOSE THE RIGHT BRUSHES

You cannot paint fog with little brushes. You will need a couple of large flat ones that are at least 1 to 2 inches (3 to 5cm) wide. For this job, choose those with natural bristles because they will hold more moisture/paint and release it more evenly. I prefer flat hog bristle or badger, but goat (hake) or squirrel will also work. A pure synthetic brush will make you think that you can't paint fog because it tends to release its load as soon as it hits the paper, which may cause the paint or water to flow in the wrong direction.

START WITH A BACKGROUND

Actually, in a watercolor the background layer is the fog. If you want gray fog, paint the background pale gray. If you want chartreuse, paint it dull chartreuse. Fog dulls colors.

For the demos that follow, we'll consider three basic backgrounds: solid, mottled and graded. Each can be used to set the dominant temperature, value and intensity for the entire picture.

FOG MAKERS
Natural fiber brushes are best for this job.

SOLID
The solid background is a pale wash of dulled color with little variation in value or color throughout, but you can set an allover temperature with this backdrop. This is a quiet, all-encompassing, multipurpose background.

GRADED
A graded background is composed of two to three soft bands of color that gently grade into each other. This background is most useful for catching the colors of early morning/evening light, or light in the forest or fields when the coolness settles close to the ground. By contrast, a gentle concentric gradation or radiating pattern of colors makes it easy to focus the viewer's eye on the light source.

MOTTLED
The mottled background can be anything from soft patches of mingled colors to full-blown clouds. The wide range of colors used makes this the most dramatic background, where the fog creates a powerful atmospheric statement.

LIGHTS CAN BE SAVED EARLY OR MADE LATER

Masking can be applied first for sun spots, sparkles, snowflakes, rooftops, etc. Light spots may also be created at the end by scrubbing with a small stiff brush, scratching with a craft knife or sanding with sandpaper.

STEP BY STEP: WORKING ON A WARM, SOLID BACKGROUND

In this approach for creating fog, we'll apply water first, then paint. Remember, the objective is to let the water do the work of moving the paint.

1. Water first, then paint
When your background wash is dry, re-wet the area you wish to have as fog (indicated here within the white dotted outline). Immediately start applying color along its upper edge with a second well-charged brush. Daubing the paint on is most effective. When the paint is flowing into the wet area the way you want it to, turn your attention to developing the top of the trees with a smaller brush. Let dry.

2. Add the lake
To add a lake that disappears into the fog, first wet a horizontal band across the fog area (inside the white dotted outline). Immediately start painting the water with long horizontal strokes of dark color, starting at the bottom of the paper and working upward. When you reach the wet area the paint will gently flow out into it.

3. Add the foreground trees
Sometimes the water used to fade out a color is added only as it's needed. For example, to add a point of land, paint in the trees from the top down using a well-loaded sponge and/or brush. When about three-quarters of the way down, wet the area below that you want for fog and then continue painting downward with your trees. When the paint hits the water, it will flow out.

4. Detail the water and finish the fog
Use a flat synthetic brush loaded with the same color used for the land to make irregular horizontal zigzag marks for waves. As the brush runs out of paint, create paler waves farther and farther back.

Darker marks suggest reflections. Add lighter highlights with a small scrub brush.

Glaze a pale blue shadow over the fog around the point.

STEP BY STEP: WORKING ON A COOL, SOLID BACKGROUND
Now let's try applying paint first, then fading with water to form the fog.

1. Paint first, then water
Start by applying a good charge of paint to define the rough shape of the land that is seen above the fog. Immediately run a damp brush along its bottom edge. Repeat the stroke until the paint starts flowing. Gradually, as the paint starts moving, make your strokes farther and farther down. When finished go to the top edge of the paint mark and define the treetops with a smaller brush.

Because there is a danger of your paint mark drying before you can get the damp brush into action along its bottom edge, I suggest that you paint large land formations in sections. Here, the left side was done before the right.

2. Develop the water
Use a flat synthetic brush loaded with a pale blue-gray to make irregular horizontal zigzag marks for waves. As the brush runs out of paint, create paler waves farther and farther back. This in combination with additional darker strokes in the foreground helps to suggest fog over the water.

3. Establish the middle ground
Add additional land forms in the middle ground using the same background land color, with a hint of dull, cool green. Fade these into the fog with a damp brush.

4. Warm it up
Since the painting feels cold and uninviting, I have added just a hint of warmth in the sky and distant fog (Quinacridone Red and Raw Sienna), and to keep the painting predominantly cool but add even more appeal, I added a pure Cobalt Blue glaze to the four corners.

The paddlers occupy the natural focal point.

STEP BY STEP: WORKING ON A MOTTLED BACKGROUND

On a mottled background, paint is applied first and then faded with a damp brush. This demo is a good example of how colorful fog can create a magical atmosphere.

1. Repeat the background colors for the trees

On this dry mottled background, paint a clump of trees with a piece of torn cellulose sponge. The colors used are the same as those used for the background, only darker: Cobalt Blue, Raw Sienna and Permanent Rose. A sponge can carry an enormous amount of paint, which makes it ideal for this situation where you want plenty on the paper for the damp brush to move. Incidentally, the damp brush I used was 2 inches (5cm) wide. Let dry.

2. Add foreground trees

Repeat this process for a second clump of trees in the foreground. This is an excellent example of how fog can create a nebulous dream world where all things are not seen nor need they be, for the feeling you're trying to create.

3. Make the focal point clear and unify with a glaze

A final few scratches with sandpaper and a craft knife along a ruler's edge provide a sparkling focal point, while a thin glaze of Cobalt Blue over the lower corners helps to unify the bottom of the picture.

STEP BY STEP: AT HOME IN THE CLOUDS

This Cathar castle in the south of France still stands, defiant and symbolic of man's desire for freedom of thought amid the clouds of ignorance and corruption that once attacked it.

1. Create a mottled beginning
A triad of Raw Sienna, Cadmium Scarlet and Cobalt Blue will be used throughout the painting, after first being used to produce a mottled background that is kept light near the top.

2. Place the castle
The silhouette of the castle is first defined and let dry, then some of the background color is gently scrubbed to give direction for the rocks.

3. Form the cracks in the cliffs
Some of the castle color is used to define the cracks in the cliffs. An irregular line first defines a crack, then one side of the line is faded out to make the edge stand out. I've tried to make it a hard climb.

4. Soften the cliffs and add clouds
To make the castle stand out, reduce the paint and contrast in the foreground by scrubbing it with a large wet sponge. When this is dry, give it a unifying and ethereal glaze of Cobalt Blue. The background clouds that give the castle a place to dwell are defined with Cobalt Blue in the same way the rocks were.

STEP BY STEP: GROUND FOG IN A RED FOREST

In this demo we will use a graded background to create ground fog.

1. Make the grade
Start by masking the roofs and window on this country cottage with packing tape, then apply an allover graded wash from warm to cool (Permanent Rose to Cobalt Blue).

2. Paint the treetops
Lay in a silhouette of treetops with a sponge. Grade the colors from warm (Quinacridone Burnt Orange) to cool (Cobalt Blue). Use a damp brush to fade the bottom of this background forest while it is still wet.

3. Add the nearer trees
Use a sponge and brush to paint the closer background trees using darker Quinacridone Burnt Orange at the top and with Cobalt Blue, grading into a cooler paler gray at the bottom.

4. Fade colors as you add them
Remove the masking from the roofs. Paint the roof a pale warm color, and paint the house a dark gray that fades into the ground fog. Grasses, which fade from dark warm in the foreground to pale cool in background, are the result of Cobalt Blue and Quinacridone Burnt Orange mixtures.

5. Develop the details
Remove the masking on the window and paint it yellow in the center with dark brown around the edges. Add darker trees in the middle ground. These also fade from dark warm color (Quinacridone Burnt Orange plus Permanent Rose) at the top to cooler paler color (Cobalt Blue) at the base. Note how the tree base and the ground are the same value. Give the foreground plants more detail.

STEP BY STEP: USING A GRADED WASH FOR GROUND DRIFTING

This is the same as the previous painting except the ground fog is now ground drifting. Ground drifting is snow that drifts or blows about one to two feet (0.3m to 0.7m) above the ground, common in any open areas that have snow.

1. A graded start
Mask the roof of the cottage first with packing tape. The background is a loose cloudy sky (Cobalt Blue, Quinacridone Burnt Orange) with a touch of pale Cadmium Scarlet for warmth. These colors will be used throughout the painting.

As you carry the sky downward, add more Cobalt Blue to cool it. Fade it out about midway through the cabin.

2. Place the background trees
For the background trees, quickly make short vertical strokes with a 2-inch (5cm) flat hog bristle brush loaded with a grayish brown. Leave the irregular brush marks for the tops of the trees. Immediately run another large flat hog bristle brush loaded with Cobalt Blue across the bottom of these strokes and fade this cool mixture downward to midway through the cabin.

3. Paint the cottage and darker, closer trees
Paint the cottage dark gray and fade it out when you get near the bottom of the wall to give the illusion of drifting snow. Then use the same gray to add darker trees around the cottage. As you paint each tree, fade out their bottoms by daubing with a tissue. Paint some pale blue mounds in the foreground for the dead weeds to fallow.

4. Finish the cottage and the foreground
Remove the masking and paint the roof a pale blue-gray. Paint the trim Cadmium Scarlet to add a little warmth.

The weeds are made by first spraying the area with water and then running the edge of a palette knife that is loaded with concentrated color through it. When the knife hits a water drop, the paint is pulled off in small bursts of color. (Practice this elsewhere first.) In order for this to work, the knife must be thoroughly cleaned using water with fine wet/dry sandpaper (available in hardware stores). When the water no longer beads up on the blade, it is clean.

Once dry, add more grayish blue mounds to the weed patch.

STEP BY STEP: MORNING MIST
Here, we will mask the light source before painting the fog and the rays of light coming through it.

1. Mask the light
An irregular pattern of dots is created by applying masking gum with the end of a small stick. Notice how the dots form the negative shape of the trees and the suggestion of movement in the water. Let dry.

Mix and mingle Cobalt Blue and Cadmium Scarlet for a background wash. Notice how the brushstrokes softly suggest light rays emanating from the sun.

2. Suggest background trees and lift rays
Background trees are only suggested by sponging on a slightly darker cool gray mixed with Cobalt Blue and Cadmium Scarlet. While wet, remove a few light rays with a damp, stiff brush.

3. Add darks and lift more rays
Add Sap Green to the mix for darker foliage in the middle and foreground. Mix Cobalt Blue and Cadmium Scarlet for the trunks and rocks. After the paint is dry, remove soft rays by lightly scrubbing with a stiff, wet brush and blotting.

4. Add more darks, remove the masking and soften
Add darker foreground reflections and rocks and let them dry completely before removing the masking. If desired, the sun spots and sparkles can be softened with a small scrub brush and water.

6 Wee People

It became quite clear to me a few years ago while painting small towns in Europe that they could be brought to life by adding a few "wee people" even when the streets were actually empty at the time. The presence of small figures in your picture can have a profound effect on its meaning and impact.

ALONE TOGETHER
11" × 15" (28cm × 38cm)

Adding Life to Your Paintings

One of strongest attractions you can add to a picture is figures. Even if they are small, your eye will still go to them. These are figures that are too far away to see facial expressions but close enough to see the all-important body language or gestures. Although one or two figures look good, they will always look better in groups where some figures are partially hidden or obscured. With practice you will also be able to enhance them by painting part of them in the negative.

Very small figures can be practiced with a pen or pencil before moving up to brush and paint.

You could also use a pen and small notepad when you want to sit and observe a crowd and study people's body language.

BRUSHSTROKES FOR BODY SHAPES
Drag a no. 6 or no. 8 round (loaded with any color you wish) sideways down the paper. Experiment with different brushes. For a wider stroke, lower your brush.

Where you position the head on the torso determines the direction the figure is looking or moving. This is a very important aspect of body language.

In a side view the head sits forward on the torso.

Front

Side

1. Paint the torso and the head
Start with a long, roughly rectangular shape for the torso. Its width depends on whether you want a front or side view. Make four of each. Then, add an oval for each head.

Don't forget that legs are overlapped in the side view.

For a standing figure to appear balanced, the feet must be located close to or straddling a vertical line from the head.

Front

Side

2. Add the legs
Now add long tapered strokes for legs using a round brush. Make them about the same length as the torso and blend into the torso. Bend at the knee if desired.

Don't worry about hands and feet unless they are important to the gesture.

One arm is often partially hidden in the side view.

Front

Side

3. Attach the arms

Now add arms, a very important aspect of gesture. Attach at the shoulders (not mid-torso) with long tapered strokes like the legs. Make them long enough to reach the bottom of a pants pocket. Bend as necessary.

IMPLYING MOVEMENT
To imply movement, place the feet so they extend beyond a vertical line from the head. You may need to counterbalance with an arm or leg.

PEOPLE TIPS

- Don't worry too much about body proportion. This will come with practice.

- Try to make your figures with the least number of brushstrokes possible. This, too, comes with practice.

- When studying people, first look for the shape and position of their torso (the first mark you make). You'll discover that it determines what you can do with the gesture. Practice making torsos with different brushes.

What could be developed from these marks?

Here are four possibilities. Try four of your own.

BLOTTING FOR HIGHLIGHTS

This technique allows you to remove paint and create sunlit areas on your figures. It helps to produce a 3-D effect.

Be ready—you must do this while the paint is still wet.

Grab the corner of a paper towel and twist it into a tight rope by twirling it around one of your fingers.

Fold the rope in half to make a tip for blotting.

Blot color off wherever the light from above would strike the figure.

BENDING LIMBS

Sometimes limbs are bent or foreshortened. They can be done in two strokes, with one portion made smaller than the other, or made as one piece with one section then blotted.

Note how blotting on the legs and arms determines which one is forward and which is back.

Here, the blotting just indicates bare legs.

WALKING
To suggest the figure is walking toward or away from you, simply shorten one leg, or bend the back leg to make it shorter and tuck it behind the forward leg. Arms can be kept at the side or with one slightly back (darker) and the other slightly forward (blotted lighter).

RUNNING
To suggest the figure is running toward or away from you, paint the bottom and top half of the legs alternately long and short. Show a bit of the shoe. Put one bent arm in front and one behind the torso.

PROPORTIONS
In terms of basic proportion, the torso of a child from the front is about as wide as their head. It gets wider as they get older. Male torsos from the front tend to be wider at the top while female torsos are wider at the bottom. This is not to stereotype anyone—simply an observation of basic male/female anatomy. Males, as well, tend to walk with their arms at their sides and turned inward, whereas females often cover their body with their arm(s) or turn their lower arms outward. These guidelines are absolutely reliable—unless, of course, the subject happens to get older or eat something. Then everything changes, and the human figure becomes the ultimate in variations on a theme. Have fun with it!

HOW DO WE KNOW THEY'RE NOT JUST CHICKENS CROSSING THE ROAD?
When we first see people at a distance, we try to identify who they are (Male? Female? Child?) and then, "What are they doing?" This is when gestures or body language tells us what going on. Head direction tells us where to look, while arm movement often indicates a connection or communication with others. For example, which figure in this group is not speaking?

ADDING COLORS FOR CLOTHING

If we slow down to paint the color of clothing as we create our figures, we risk losing the spontaneity and charm of single brushstrokes.

The easiest way to add color is to either drop it in while the original color used to create the figure is still damp, or let the original color dry and then paint the clothing color on top. A third option is to paint the whole figure in one color and then blot the area you want for clothing. You can add color to this area when it is still damp, or when it dries. We really are painting clothes, and sometimes people wear clothes of one color, such as business people and uniformed personnel. In these cases, it is easier to paint the whole figure the color of the clothing and then lighten or darken the head for contrast.

Don't forget that clothing often determines the initial shape you make.

Cobalt Blue and Indigo were dropped in while the body paint (Red Rose Deep) was wet.

The body color was left to dry before a check pattern was created on the shirt, green added for the vest, and blue applied for the pants.

The body color was blotted for the shirt and the pants. While this was still damp, green and blue were added.

The body color was blotted and left to dry, then the design on the shirt was added.

BLOTTING FOR SINGLE-COLOR OUTFITS
When the body is covered in clothing of one color, paint the initial figure in that color and then blot for the light areas.

HATS
You can have lots of fun with variation here. Often it's the brim that indicates "hat." Darkening under it and blotting the top helps with the illusion.

POSITIVE AND NEGATIVE
It is hard to do these wee folk without eventually getting into positive and negative painting. By having figures that are positive on one end and negative on the other it provides a wonderful chance to add contrast and depth in the background.

Now the background is used to complement the figures.

Negative painting also allows for light-colored clothes.

WHEN NOTHING IS SOMETHING
The best way to depict clothes that are white or light-colored is to not paint them at all if the background is the desired color. Just add what isn't white. If the background is dark, you must save the whites right from the beginning by negative painting or masking.

POWER IN NUMBERS
Wee figures always look better in a crowd where they can add interest to the painting with their interaction with each other. When they are crowded together, you'll only see parts of some figures.

PENNING DETAILS
Here, a black pen was used to add detail to some wee people wandering around an Italian piazza.

WORKING WITH THE BACKGROUND COLOR
Painting in the positive and/or negative on a painted background eliminates the need for clothing colors, and fade-outs add mystery.

7 Working with Photographs

I rarely work from photos. If I do use them, it's for one of two reasons: first, to provide a visual stimulus that will jump-start my memory and imagination; or secondly, as a way to capture a subject's detail accurately.

Regardless, I've included this chapter in the book because I see so many fellow artists using them without realizing the tremendous opportunity they have in their hands to do something really creative instead of just copying the immediate image.

Whether you work from photos or not, this section offers a wide range of ideas to try with any painting approach.

YOU CAN'T SEE ME
15" × 22" (38cm × 56cm)

So, Let's Get Started

Have you ever noticed that the pictures you take don't always match what you remember seeing? They're accurate but something is missing. You recall taking the picture but it doesn't seem to capture what you remember of the occasion. The reason is that cameras don't have a "feelings" setting on them. They can only show you how things looked. They cannot convey how you felt or the spirit of the moment when you took the picture. That's your job as an artist; to recreate the scene in a way that conveys the original feeling or a feeling you wish to create. But we want to go beyond that.

The hardest thing to get past is the idea that your painting must adhere exactly to what the photo represents in terms of time, place or event.

I realize that you may wish to paint a photo as close to the way it appears as possible because you think that it would make a good painting or that it represents an occasion, location, object or person that you want to record accurately in paint. That's fine. Do it. Enjoy yourself. However, if you go further in this chapter you will be asked to do creative things. You will be challenged to go beyond being a painter to being an artist.

My objective is to have you realize that you will get more out of your photos if they're used as raw material in need of nurturing, or as a stimulus or starting place instead of the end result.

The first part of this chapter examines ways to make simple cosmetic changes while still keeping the photo's essential image. Then we will explore ways of making structural changes to the photo to create an entirely new composition. Finally, we'll look at ways of adding and combining parts and pieces of your photos plus external ideas to create something entirely new.

Start by picking eight to ten mediocre photos of varying subjects and seasons to work with. As we go through the suggestions, take your time to really think about them in terms of your own photos. As you get into this further, you will want to add more photos.

Playing the What Is 'It' game.

WHEN WORKING WITH PHOTOGRAPHS
All you'll need are eight to ten so-so photographs, a sketch pad, a ballpoint pen, a pencil, and two cardboard L's (the corners of an old mat work well for this). You might also make use of a mirror and a color wheel.

PART I: COSMETIC CHANGES

Add Drama

Add drama to a painting by exaggerating the sky conditions shown in the reference photo and reinterpreting colors to produce a distinct mood.

BORING CLOUDS IN A COLOR COMA
The gentle, broken overcast sky is calm and peaceful because the clouds are horizontally oriented, but the photo also lacks a more exciting color dominance.

AFTERNOON SHOWERS
11" × 14" (28cm × 36cm)

AWAKEN THE SKY WITH A COLORFUL REDESIGN
The sparkles on the water were created by applying masking gum with a stick and toothbrush. I then chose dominant colors for the sky, land and water that would create a warm, moody effect (Indigo, Quinacridone Violet and Ultramarine Blue). The sky was done by laying down large patches of dark color along the top of the sky. The paper below those patches was then given a coarse spray of water and tilted so that the paint would run down the page and give a diagonal direction and more energy to the clouds. This process was repeated with more paint and water after the first coat dried. The water was then painted with horizontal brushstrokes using the same colors. When all was dry, the land was painted by mingling the same colors but with more Indigo.

COSMETIC CHANGES
Tilt Your Whole Picture

A viewfinder made from the corners of an old mat (or two cardboard L's) is needed for this. By slightly tilting the photo, you can easily create a far more dynamic painting. The important thing here is to keep the viewfinder level while you slowly turn the photo. Photos that do not have a strong natural horizontal reference, such as a large body of water, will work best.

If you wonder about how effective this approach can be, check the work of professional illustrators, commercial designers, photographers and comic book or cartoon artists. You'll see it used often. You just may want to start tilting your camera when you take pictures for a more dramatic effect.

REFERENCE PHOTO

Adjust the size and format of the viewfinder opening.

Rotate the photo and observe the new picture possibilities.

Some photos work better than others, so experiment with a variety of them.

COSMETIC CHANGES
Flip the Entire Picture

Sometimes you will get a stronger, fresher picture just by reversing it. Simply look at your picture in a mirror to determine if it would be worth flipping. Pay attention to how your eye reads the scene. Let your intuition guide you.

When the art police show up, just show them your artistic license.

HOW FLIPPING A SCENE
CHANGES WHAT YOU SEE
In this case, since we read from left to right, our eye moves easily with the flow of the stream in the version on the right. In the version on the left, I may experience more of the stream because I had to fight my way up it, through the rapids.

COSMETIC CHANGES
Change the Time of Day

Will your scene happen at sunrise, midday, late afternoon, twilight, or night?

If you choose late afternoon or early morning, you get to lengthen shadows and use them to define the contours of other shapes. If you include shadows from objects that are outside the photo, it gives the feeling that the picture extends beyond the edges of your paper.

If you choose to convert your scene to night (dusk or dawn), you will have to decide on alternative light sources such as street lights, campfires, headlights, candles, windows, the moon and so on. The choice then is whether the light can be seen directly, as with a headlight, or indirectly by what the light source illuminates or bounces off of, such as the surface of a body of water.

REFERENCE PHOTO
An overcast, midday view from a hilltop.

DAY'S END
14" × 11" (36cm × 28cm)

AT THE START AND END OF THE DAY
By casting the light (using light, warm colors) on the rock face and the top of the islands, one can suggest a morning or evening sun.

MOON'S PERCH
14" × 11" (36cm × 28cm)

AT THE RISING OF THE MOON
The moon's reflection changes the lighting and mood in this version.

97

COSMETIC CHANGES
Change the Atmosphere

By intentionally manipulating the quality of our colors, values and detail, we can create whatever atmosphere we want in a picture. Flip back to pages 20–21 of chapter 2 for more on how atmosphere can affect a scene.

REFERENCE PHOTO
Buildings in Rennes-le-Château, France.

SUNNY AT RENNES
11" × 14" (28cm × 36cm)

WHEN THE SUN COMES OUT
By using warmer and purer colors, sharper detail and darker shadows, I can suggest sunshine in my scene.

LILACS IN THE MIST, RENNES
11" × 14" (28cm × 36cm)

THE QUALITY OF LIGHT AFFECTS EVERYTHING
As moisture in the air increases, the quality of light changes from bright to diffused. We see less detail, and edges get softer. Colors become dulled, and the degree of contrast in values decreases.

COSMETIC CHANGES

Change the Season

This is one of the simplest changes to make and one where you really feel like you are controlling the picture. Changing the seasons can involve changes to many parts of your picture, including the sky, the trees and the ground. Try changing your scene to winter first; you'll save paint and not have to worry about a lot of ground detail.

TRANSITIONS SPARK INTEREST

There is more drama when natural conditions are changing from day to night or night to day, from season to season, or from one type of weather to another. It gets the viewer involved by making them think about what's passed or coming. For example, a winter scene that includes the remains of autumn or signs of spring may have more appeal than the pure, cold depths of winter. However, even winter's cold can be tempered with warm colors.

REFERENCE PHOTO
An abandoned home where I'm sure love and joy once flourished.

THE LONG SLEEP
11" × 14" (28cm × 36cm)

WHEN MEMORIES ARE ABANDONED
Even though the old home is set in the winter, the warmth of the colors reflect the cherished memories it once gave birth to.

COSMETIC CHANGES
Add Shadows

As shadows define the contours of what they fall across, they also add visual pattern and interest. They can be quickly laid on wet-on-damp for the first layer and then wet-on-dry for the final layer. An important tip for this method: Mix a large batch of the shadow color you plan to use in a separate tray, so you have enough of the same color for both layers.

Another method is to paint the entire snow area with a non-staining blue-gray (Cobalt Blue or Ultramarine Blue plus Burnt Sienna). Once this is dry, you can remove the sun spots by scrubbing them off with lots of water and a small scrub brush.

REFERENCE PHOTO
An overcast winter walk.

LIGHTING THE WALK
11" × 14" (28cm × 36cm)

CREATING SHADOWS BY REMOVING PAINT
The shadows shown define the structure of the land. To create them, I used the second method—painting an all-over layer of color, then scrubbing out the lights using a small hog bristle scrub brush and plenty of water. (To make your own scrub brush, see page 16 of **The Watercolorist's Essential Notebook: Landscapes**.)

COSMETIC CHANGES
Find Variations in the Value Arrangement

You can find some interesting variations simply by changing the light direction in your photograph as done in the thumbnail sketches below. We'll talk more about thumbnail sketches later in this chapter.

REFERENCE PHOTO
Late winter afternoon sun on a farm road

Sun from behind as in the original

Sun from the left

Sun from the front

Sun from the right

101

COSMETIC CHANGES
Add Outlines, Shading, Texture and Detail

After you have painted your picture, you could use pen and ink, roller ball pens, graphite pencils, ballpoint pens, colored pencils, chalk or markers to outline shapes, add detail or create cross-hatch shading in your picture.

Pay attention to the weight of your lines. More important shapes deserve heavier lines than less-important ones. You may wish to outline only the important parts of your picture.

BEFORE
Field sketch of boulders on the lake shore.

CRUSHING INFLUENCE
11" × 14" (28cm × 36cm)

AFTER
With outlines and hatching marks added.

BEFORE
This was a demo I did to show how to create a hillside forest using interlocking positive and negative tree shapes.

AFTER
Any permanent-type marker of any color can be used to outline shapes in your paintings. Here, a Uni-Ball Signo white marker was used instead of a black one for a startling, graphic effect.

COSMETIC CHANGES

Highlight an Important Area

Regardless of how you have painted your picture, it can always benefit from focusing the eye on a light and/or high contrast area. Basically, the eye is attracted to light areas and ignores (but feels) the darker ones.

For example: In the original painting shown on this page, the contrast of the dark evergreens is already established, but now I wish to shift attention to the light, warm trees to the left.

This is done in two ways. The first is to paint grasses in a gradation from light in the distance to dark in the foreground, by making short, progressively darker vertical strokes with a flat hog bristle brush and letting it dry. The second step is to darken unimportant areas of the picture by glazing them with a coat of grayed blue (Cobalt Blue with a touch of Burnt Sienna). Glazing takes nerve because you are intentionally putting seemingly unnecessary paint on top of a perfectly good painting, and you must do it quickly to avoid disturbing what's beneath it, using two wide, flat brushes—1½-inch to 3-inch (4cm to 8cm). One brush carries paint and the other, water.

First, imagine where you want the painting to be made darker and then roughly where you want this darker paint to fade out. Start by wetting this fade-out area, and then immediately begin painting on the medium blue-gray with the other wide brush, working your way with big strokes toward the wet area. When you get there, keep brushing across the wet area until the gray fades out.

Repeat this darkening process in other areas until you are left with the desired light focal area.

PHOTO—ACCURATE BUT UNEXCITING
This painting is close to what the photo was, but the light warm trees can be helped by focusing the light on them.

DISTANT POND
11" x 19" (28cm x 48cm)

ADDING DRAMA BY FOCUSING THE LIGHT
By darkening the upper right corner, right side, across the whole bottom and partway up the left side, I am able to focus your eyes on the remaining light area. A thin, light line was added for water in the distance.

COSMETIC CHANGES

Give Your Painting a Distinct Color Scheme

Instead of using the colors in your photograph, you may consider emphasizing a particular color combination or temperature for your picture. The following demo paintings give some examples.

BALANCING WARM AND COOL COLORS
In the process of getting a balance between a couple of warm colors (Burnt Sienna, Raw Sienna) and a couple of cool colors (Cobalt Blue, Indigo), a wide range of dulled colors ended up being created. Do trees have to be green and fog white?

UNUSUAL WATER COLOR PRODUCED BY MIXING
Here an unlikely range of dulled warm colors produced by mixing Cobalt Blue, Cadmium Red Light and Quinacridone Burnt Orange was used to portray water.

BALANCING PURE WARM AND COOL COLORS VISUALLY
The heat of Quinacridone Burnt Orange is used to visually balance the coolness of Phthalo Blue and Phthalo Green in this water scene.

FEWER COLORS OFTEN HELPS
Create harmony by restricting the number of colors you use. In this demo painting, Phthalo Blue and Permanent Rose create their own dance without a third cutting in.

BRING LIFE TO MONOCOLORED AREAS IN YOUR PHOTO
You can make exciting variations in areas that are basically one color by mingling other colors into them (see chapter 4 for more on mingling).

PART II: STRUCTURAL CHANGES

Building a Better Composition

To call ourselves artists, there must be evidence that we somehow made decisions about the composition (that's everything the viewer sees). On the pages that follow, we'll explore the types of structural changes we can make. This means making changes to what is and where things are in your photo in order to build a stronger composition and a picture of your own making.

STEPS IN CHANGING A COMPOSITION
Now your painting starts becoming less and less like the original reference photo. Follow these steps to make compositional changes.

1: ANALYZE
Identify the most important objects or aspects of the photo—the reason you took the picture in the first place. This will probably become your focal point. Note how lighting or atmospherics may have played a role.

Try turning your picture upside down and squint. Now the big shapes, major lines and value levels and distribution in particular become easier to read. What becomes obvious are places that lack contrast in values, making it hard to see important shapes and detail. This may need to be dealt with later.

Oddly enough, you may also be able to see colors and atmospheric effects better upside down than right side up, but more importantly, the major lines which indicate the edges of shapes and boundaries of different values stand out more easily. Pay attention to them because they are candidates for change, because they constitute the framework of your picture. It is those lines that can be manipulated to provide a better division of picture space and path for the eye while adding energy to the whole picture.

2: DECIDE WHAT TO KEEP AND WHAT TO ELIMINATE
Don't assume that just because it's in the photo, it has to be in the painting or even appear in your painting the way it is in the photo. It is really a matter of choice, but basically don't keep anything that is irrelevant or that might upstage the main players in your picture.

They may be lesser objects or details that can be included but suppressed, simplified or obscured by blurring, darkening, dulling or fading during the painting process. That way they are just bit players adding side interest for the viewer.

3: IMAGINE THE POSSIBILITIES
The best tool you have for visualizing changes and variations to your photo is thumbnail sketches. These miniature sketches are the fastest, most effective ways to gather and manipulate data about a subject. You can make five or six of them in the time it takes to produce one traditional sketch. By working small, you have no time to fuss over detail while indicating only the major lines, big shapes, patterns and values in the photo you are working with.

They give you a chance to visually "think out loud" and see picture possibilities without a lot of work. If your sketches are so large that they slow you down or you start getting picky, you've missed the point.

BIG TIP: It's worth mentioning again that as empty spaces develop in our compositions, we should strongly resist the temptation to put something in them when actually just changing the value of the area or using a passage of graded or mingled colors would fill these spaces without cluttering the painting.

Thumbnails are teeny tiny drawings about this size.

"Psst... wanna buy some dirty thumbnails?"

106

MAKING THUMBNAIL SKETCHES

Start with the right tool. Ballpoint pens, preferably black, are recommended because you can actually make light lines and even shade with them like a pencil by varying the pressure and yet go darker than a pencil when needed.

Start with light lines and then apply darker ones as the sketch progresses. Avoid using gel, roller ball or felt-tip markers because they make only one degree of darkness: black.

REFERENCE PHOTO
A rocky shoreline.

1. Draw major lines
Start by drawing in major lines (edges of shapes) and roughly defining the location of the focal point. In this case I have added kayaks that were in the area, because I want to call my picture *Better than Walking*.

2. Refine edges and add shading
Continue adding darker lines to refine edges of shapes while shading in areas of medium value.

3. Continue shading and refine values
Finish by shading in the darkest values while refining value gradations and contrasts between shapes, saving the lightest area for the focal point.

FINDING VARIATIONS

Once you understand the making of thumbnails, you can start playing with new compositional possibilities from your photos.

REFERENCE PHOTO
Here are four thumbnail variations from this farmhouse photo that could become future paintings.

Farm at dusk

Farm by moonlight

First rays of light

In the corner

107

STRUCTURAL CHANGES

Creating a Hit

Pretend that the picture you hold in your hand is the makings of a stage play and you are the director. Here are some aspects or variables, in no particular order, that you might like to consider in order to create a hit.

- **Lighting.** Would a change of light intensity or direction help? Are shadows placed so they help to define contours or help to frame the center of interest? Have you considered removing the sun and making it a night scene lit by the moon, a lantern, a campfire or a street light? Does the focal point (center of interest) get the best lighting and contrast?
- **Division of picture space.** Have shapes and lines broken up the picture space unevenly (in a pleasant way), with roughly one large, one medium and the rest of the pieces in assorted sizes?
- **Center of interest.** Has it been located to appear away from the direct center, edges and corners of the picture? Will there be contrasts of color and value to set it off and ways that lead your eye to it? Have you eliminated or suppressed anything that may upstage your center of interest?
- **Movement.** Have you positioned major lines or tilted shapes to suggest energy and movement? Have you used flowing lines to suggest motion?

LILIES IN THE LOOKING GLASS
14" × 22" (36cm × 56cm)

VALUE CONTRASTS
These characters and their reflections appear to be getting the best lighting because of the sharp contrast between them and the surrounding darker, duller background.

TOOL SHED ANALOGY
14" × 22" (36cm × 56cm)

ORBITING THE FOCAL POINT
I used the doorway and the surrounding tools and junk to frame the inner focal points. Can you see the parallel between this picture and a royal kingdom or a modern-day corporation?

- **Unity.** Can you create unity through dominant features, such as:
 Value—Will the picture be predominantly dark, medium or light?
 Temperature—Will the colors be predominantly warm or cool?
 Atmosphere—Would a dominant mood or atmosphere help the picture?
- **Framework.** Are you planning to use a "structure" for your picture, such as a zigzag, a hook or a variable repetition? (See pages 24–28 of chapter 2.)
- **Color.** Would the use of gradations, reversals, mingling of colors and passages add interest and variety? (See chapters 3 and 4.) Could you change the colors to suit a particular color scheme or reflect the feeling you want to convey or the essence of the subject? Perhaps completely surreal characters would make the story.
- **Wee people.** Would adding one or two (or more) enhance your picture? (See chapter 6.)
- **Wetness.** Have you used techniques that make use of variable wetnesses (wet-on-wet, wet-on-damp, damp-on-wet, wet-on-partially wet, etc.)? These are the signatures of watercolors and a measure of your mastery of the medium.

BACKWATERS
11" × 14" (28cm × 36cm)

ATMOSPHERE
The dominant atmosphere for **Backwaters** was created with an initial background wash graded from warm (top) to cool (middle) to warm (bottom). Pale tree trunks and land plus scrubbed-off sky light patches and dark trees up close added to the illusion of haze.

WINTER OPENING
14" × 22" (36cm × 56cm)

WATER WORKS
This painting, though a balance of warm and cool, light and dark, and hard and soft shapes, is also an example of letting water do the painting. The upper half is damp-on-wet followed, when dry, with wet-on-dry. Reflections are wet-on-partially wet; snow shadows are also wet-on-dry.

STRUCTURAL CHANGES
Zoom and Crop

The easiest and most obvious way to alter a composition is to zoom in and crop the photo using a viewfinder made from the corners of an old mat. Move it around until you find an arrangement and format that appeals to you, keeping in mind the location of your center of interest. Most of us have the bad habit of taking photos with our subject located dead center in the picture. Cropping and zooming gives us a chance to relocate our subject to a more dynamic position. Use a mirror to see if it would make a more interesting picture if flipped, and don't forget that tilting can add more excitement as well.

You'll soon realize that changing the format and orientation of your paper changes how you treat your subject, and how each format has its own compositional advantages.

The cutting chart on the next page may be of help in this regard.

ORIGINAL PHOTO
Many of our photographs contain other potential compositions.

Use a viewfinder to help you find a new composition.

Traditional format

Panoramic format

Vertical format

CUTTING WATERCOLOR PAPER INTO FORMATS

This chart is designed to help you cut your 22" x 30" (56cm x 76cm) watercolor paper so it's close to the format that results from zooming and cropping but, most importantly, of a size and format that can be framed easily.

NOTE: **Bold dimensions** = frame size with 3" (8cm) mat all around and ½" (13mm) minimum paper overlap.

15" (38cm) | 15" (38cm) — 22" (56cm)
- ½ sheet **20" × 27" (51cm × 69cm)**
- ½ sheet **20" × 27" (51cm × 69cm)**

15" (38cm) split into 11" (28cm) top / 11" (28cm) bottom sections:
- ¼ sheet **16" × 20" (41cm × 51cm)**
- ⅛ sheet **11" × 14" (28cm × 36cm) 2" (5cm) mat**
- ⅛ sheet **11" × 14" (28cm × 36cm) 2" (5cm) mat**
- ¼ sheet **16" × 20" (41cm × 51cm)**
- ¼ sheet **16" × 20" (41cm × 51cm)**

19" (48cm) | 11" (28cm) — 22" (56cm)
- ⅝ sheet **24" × 27" (61cm × 69cm)**
- ¼ long / ¼ long / ¼ x-long

19" (48cm) | 11" (28cm) — 11" (28cm) / 11" (28cm)
- ¼ sheet long **16" × 24" (41cm × 61cm)**
- ¼ sheet long **16" × 24" (41cm × 61cm)**

You have a choice of sizes to cut from this piece

25" (64cm) | 5" (13cm) — 22" (56cm)
- ⅞ same proportion as ⅝ **27–28" × 30" (69–71cm × 76cm)**

11" (28cm) | 11" (28cm) | 8" (20cm) — 22" (56cm)
- ¼ sheet x-long **16" × 27" (41cm × 69cm)**
- ¼ sheet x-long **16" × 27" (41cm × 69cm)**
- ⅛ sheet **11" × 14" (28cm × 36cm) 2" (5cm) mat** — 11" (28cm)
- ⅛ sheet **11" × 14" (28cm × 36cm) 2" (5cm) mat** — 11" (28cm)

30" (76cm) — 14" (36cm)
- ⅔ long **20" × 36" (51cm × 91cm)**
- ⅛ sheet **11" × 14" (28cm × 36cm) 2" (5cm) mat**
- ⅛ sheet **11" × 14" (28cm × 36cm) 2" (5cm) mat**
- 8" (20cm)

30" (76cm) — 18" (46cm)
- ⅚ long **24" × 36" (61cm × 91cm)**
- 4" (10cm)

STRUCTURAL CHANGES
Exaggerate or Refurbish

We are allowed to distort land forms, trees, figures, flowers and so on to emphasize the spirit of the subject. Your photograph captures what is there. Your painting should reflect how you felt to be there.

BEING THERE
The highway through the hills to the north of Lake Superior

WHEEE!
What it feels like to drive the same highway. The key word here is "feels." My painting should have some **"Wheee!"** in it.

RELIC OF THE DAY
This is not just a derelict mine shaft but a monument to a bygone era.

SILVER LINING
15" × 11" (38cm × 28cm)

REFURBISHED GLORY
I've tried to capture the spirit and energy of the day when this shaft and many like it took their place in history.

112

STRUCTURAL CHANGES

Change Your Point of View

There are two ways to change your point of view. The first is to change the level from which you are viewing the subject, i.e., how far below or above it are you? In terms of perspective, that means that you are changing your eye level. Basically what happens is that the higher you get above objects, the more spread out they get and the more you can see the curvature of their edges.

Viewing from various elevations

LOOKING DOWN
View from Devil's Rock.

ABOVE DEVIL'S ROCK
15" × 11" (38cm × 28cm)

A DRAMATIC STRETCH
To give the impression that I am viewing the scene in the photo from a higher elevation, I increase the sense of distance by spreading out the land shapes vertically, which creates the dramatic illusion of flying down the lake.

The second way to change your point of view is to stay in place but change the viewing angle, much as you would if trying to frame a picture with a camera.

This can change the whole focus of a painting. When looking at your photo, imagine what it would have looked like if you had pointed the camera slightly up, or down, or left or right.

Changing your viewpoint allows you to use your imagination to add in other interesting material and shift your focal point. For example, if you shift upward, you will be able to do interesting things in the sky. If extended downward, you'll be able to add something of interest in the foreground.

Viewing from one location

REFERENCE PHOTO
Here's the original view of this subject. Let's shift our gaze to examine other compositional possibilities.

Looking right

Looking left

Looking down

Looking up

114

A VIEW FROM ABOVE OR BELOW

A mundane subject can come to life by simply taking a view of it from above or below. Start by finding or taking photos of your subject that can be used for this challenging and refreshing view. In most cases you will have to construct your composition from numerous photos and your imagination.

PLANTING TIME 3
22" × 15" (56cm × 38cm)

Perspective is important even from above.

LILY PICKERS
19" × 22" (48cm × 56cm)

It is not necessary to show all of the subject.

ROYAL VISIT
15" × 22" (38cm × 56cm)

Here we are looking up and down in the same composition.

STEP BY STEP: LOOKING UP

We are often reminded of how we fail to see what's at our feet as we tramp through life. The same can be said of what's over our head, but I'm sure most of us, at some time, have gazed up through the splendor of an autumn canopy. Painting this in watercolors can be a challenge. Because some leaves are light against the sky and some dark, it's hard to accommodate both with a pure blue sky. This method may help.

Warning: This technique requires paper that can take a real beating. I have used 140-lb. (300gsm) Arches here.

REFERENCE PHOTO
Looking up through the treetops.

1. Coat with color, then apply masking
Begin by giving your paper a rich coat of light and dark non-staining autumn colors (Lemon Yellow, Raw or Burnt Sienna, Cadmium reds and oranges; mix green with Cobalt Blue and yellows). When this is dry, create a pattern for the leaves by liberally applying masking fluid with a piece of torn sponge. Let dry thoroughly.

2. Remove color
At a sink, use a Magic Eraser and plenty of water to scrub off any color not covered by the masking fluid. Let dry.

3. Wash in the sky
Give your painting an allover wash of sky blue (Cobalt Blue or Ultramarine Blue) that is darker in the corners than the middle.

4. Remove the masking and add darks as needed
Now remove the masking to reveal the bright autumn colors beneath. Some areas of the canopy are in shadow and so will need to be darkened. Use darker warm colors; do not darken by mixing with blue. This brushwork can enhance the leafy pattern throughout.

When dry, use a very dark color for contrast (a mix of Ultramarine Blue and Burnt Sienna) to add converging tree trunks and branches. A center of interest is hidden in the leaves. Do you see it?

STEP BY STEP: FRONT AND CENTER
Here, a single object from a photo is made the lone star of your picture.

REFERENCE PHOTO
The artist facing down her subject.

1. Mask the subject and paint a dramatic background
Use packing tape to mask out the figure on the paper. (Tip: Use a very sharp craft knife to cut the tape. Arches paper recommended.) After pressing it down, create a dynamic background to suit the nature of your subject.

2. Add an interesting pattern to your subject
Give the unmasked subject a loose spray of water and drop diluted background colors into it along the bottom of the paper and tilt it upward. Keep adding color and carefully spraying to move the paint into an interesting pattern. Colors that run into the background can be blotted while wet. Let dry. This whole process can be repeated to build up a more complex pattern.

3. Add minimal subject detail
Using the same colors from step 2, add internal shadows to define edges. Scrubbing was done here to add more light to the sky.

PART III: CREATIVE CHANGES

Creatively Combining Photos, with Some Ideas from Outside the Paint Box

In the last part of this chapter, we'll explore adding and combining parts of photos, and we'll also look at other ways to get creative with our compositions. Your only limit is your willingness to let down your guard and let out your imagination.

CANOE DREAMS
19" × 22" (48cm × 56cm)

MAPPING IT OUT
In this painting, a canoe crosses a map of old fishing holes. The canoe, water lily pads and flowers were masked out. That way I could focus on the map which was darkened under the canoe and flowers to suggest deepening water. A few ripples helped. Then the canoe was painted.

CREATIVE CHANGES

Combine Parts of Photos

Combine parts from one or more photos with another. This could take several forms.

INTERCHANGE OBJECTS AND BACKGROUNDS

Use one photo as a background for objects taken from another. Using objects with interesting contours or point of view and tilting them will add interest and energy. There are many natural combinations you could try—a butterfly from one with flowers from another; kids from one with mud puddles from another. The potential combos are endless. This can be extended to create a whole new composition by bringing together individual elements from various photos. For example, birds from three photos could be combined to make a new picture. The same goes for flowers, people, buildings and so on.

You may be able to create a more dramatic effect if you use the background from one picture as background in another. This was done when a different sky was used to enhance the foreground in the painting on page 94.

TRY A VALUE CHANGE

An interesting foreground in one picture can be reused as such in a darker or lighter form in a different picture. In fact, large objects in one picture—large tree trunks, people, pillars, machinery, a door or window frame—can frame an important area in another picture. These objects can often do their job better by being painted as dark silhouettes or masked as a white silhouette. In either case, they increase a sense of depth in your picture.

NICE GROUP EFFORT
Each of these photos of Jack-in-the-Pulpit contributed to a new composition called **Garden Seminary**.

GARDEN SEMINARY
22" × 15" (56cm × 38cm)

CONSIDER CROSS SECTIONS

You could also weld part of one picture to another, as shown in the underwater and above-water photos on this page. Consider other possibilities, such as inside/outside, underground/above ground, night/day and summer/winter.

MAKE A VALUE CHANGE
The fence from one picture can be used in light or dark silhouette to enhance a second picture.

FIRST PHOTO
A snowy fence

SECOND PHOTO
A warm winter sunrise

COMBINED PHOTO COMPOSITION
Now the warm and cool of winter enhance each other.

FIRST PHOTO
Underwater view

SECOND PHOTO
Lake view

WELDED PHOTO COMPOSITION
An above and below the surface view offers a chance to create a visual story with the addition of a boat, some fish, or a shipwreck.

CREATIVE CHANGES

Change the Scale and Situation

All the previous examples combine pieces that are about the same scale, except when you may have part of something that is very large in the foreground for the sake of depth.

Now, let's have fun.

Let's free up our imagination by combining things that are of a different scale in close relationship to each other. This is when worlds collide—when the impossible, fanciful, magical and often humorous things happen. Don't be afraid of subtle humor and the whimsical. It's good for the digestive system and quite often conveys a profound message or different point of view better than any other way.

ORIGINAL PHOTO
A Tuscan doorway

CREATIVE COMBO
You never know what's outside your door, especially if you're an artist. Here, a watery planet has just moved in.

WHAT DO YOU SEE?
I've always thought that the sand at the beach looked a lot like the Grand Canyon.

BOULDER DWELLERS
7½" x 7½" (19cm × 19cm)

LOOK CLOSER
You're looking at a cluster of rocks, but are they small or big? This painting is about a little-known tribe in the American Southwest.

CREATIVE CHANGES
Add a Transparent Element

Remember the "double exposures" from print and slide film cameras? We can create that multi-image illusion again if you paint one picture on top of another using non-staining, transparent watercolors.

Assuming that you already have a background picture, the task now is to create an image that can be superimposed on it. The catch here is to keep the image you apply from hiding the good bits in the one below, and vice versa. You'll also get a better effect if the image you apply, be it from a photo or of your own making, is of greater scale than the one in the background.

You have two choices here. You could sketch out the new shape to be applied on tracing paper or acetate and cut it out. This way you can move it around until you find a good spot for it and then trace it.

Another method I use is to sketch out the object so it fits on a piece of stiff paper that's about 4" × 6" (10cm × 15cm). I cut it out and tape it to a small stick. I can then hold that image in front of my painting and, with one eye closed, zoom it in and out and around until I see a location that would work. Once I do, I steady my arm tight against my body, keep one eye closed, and then draw the outline with my other hand. Once I have the rough outline down, I can play with its accuracy and details.

Don't worry about the colors of your new image at this point. I have found that a transparent, non-staining gray made by mixing Cobalt Blue or Ultramarine Blue with Burnt Sienna or Quinacridone Burnt Orange is a good way to start. This allows you to apply warm or cool, light or dark color as needed.

The most important decision is whether to paint your image in the positive or negative, or maybe with a bit of both.

Where you paint it in the positive, pay attention to the level of darkness. You may want to blot off or fade areas or soften edges with a damp brush.

If you paint in the negative, you will be defining the outer edges only in areas of importance. The paint, which can vary in darkness, is faded outward from the shape.

The hint of other colors (for example, giving a fisherman a yellow slicker) can be glazed on top of your grays if you wish.

PLACING THE ELEMENT
The cut-out shape of a fisherman is taped to a stick and moved around in front of the background picture until a desired location is found. It is then sketched in.

CATCH OF THE DAY
11" × 14" (28cm × 36cm) field study

PAINTED IN THE POSITIVE AND THE NEGATIVE
Some areas of the fisherman are painted in the positive and some in the negative. For better contrast, the top of his hat and left forearm are lightened beforehand by scrubbing.

LAKEWAY SPIRIT
14" × 22" (36cm × 56cm)

A SUBTLE SYMBOL
This picture was painted to mark the closing of this school. Its symbol was a Trojan. Can you see him, painted entirely in the negative?

COMBINING OTHER PAPER MATERIALS WITH PHOTO IMAGES

By "other paper materials," I'm referring to anything that is printed on paper. That could include menus, sheet music, receipts, bills, tickets, brochures, house plans, assembly instructions, maps, recipes and on and on. In this process you are marrying the image from a separate piece of paper with an idea from a photograph or a painting you have already started.

We could glue the piece of paper on the painting and combine with layers of tissue and rice paper to form a collage, but there are other more painterly approaches to try first. We want the idea or image that's on the paper to appear to be an integral part of the painting, and this involves transparency.

CREATING THE ILLUSION OF A TRANSPARENT IMAGE BY TAPING AND SCRUBBING

Let's say, for example, you wish to combine a painted image with the building plans for some object in the painting. One way to do this is to draw the plans on your watercolor paper with a black waterproof pen (I recommend Uni-ball Vision) *before* the picture is painted. When the picture is painted and dry, define the perimeter of the plans with packing tape and then gently scrub off some paint inside with a damp sponge to reveal the plans and some of the painting below. Remove the tape to reveal the illusion of the sheet they're on. (This is described in greater detail on page 56 of *The Watercolorist's Essential Notebook: Landscapes*.)

ROUNDING THE POINT
11" × 19" (28cm × 48cm)

WHEN PLANS COME TO FRUITION
This painting commemorates the planning and building of a canoe and the end results.

BEFORE
A painting found during a recent archeological dig in my studio. It was already finished before it was modified with the addition of house plans.

COUNTRY LIVING
14" × 11" (36cm × 28cm)

AFTER
The sheet for the plans was first scrubbed off as above, but the plans were not drawn on with a lightproof marker until the paper was thoroughly dry.

CREATIVE CHANGES

Add a Piece of Paper to Your Painting

It is not my intention to write a book on collage, but I do wish to offer enough technical data and ideas to help you investigate this vast area on your own if you wish.

ADHESIVES
There are numerous quality water-soluble paper adhesives out there. Make sure that whatever you use is acid-free and will not yellow or give up its adhesive ability with age. Water-soluble adhesives, including acrylic polymer emulsion and "Yes!" glue are compatible with watercolors.

EDGES
Sometimes you will want to keep the hard edges of the paper you are adding, and sometimes you will want to soften them by carefully tearing them. The thinner the paper, the easier it is to work with. Some semi-transparent papers can be used to obscure the view of a subject, or to add pattern and texture to your painting. Tissue and rice papers, which come in an endless variety, are good for this.

PLAT DU JOUR
11" × 14" (28cm × 36cm)

EVEN IN THE FINEST OF RESTAURANTS, IT DOESN'T GET ANY BETTER
Here, a pretentious menu is created on the computer, printed on a piece of 90-lb. (190gsm) acid-free, hot-press paper with a laser printer (laser printer ink is waterproof) and added to a painting that was inspired by several photos and some good catches. In this case I coated the back of the menu with polymer emulsion and let it dry. I then recoated it, placed it on the painting and rolled it down using a brayer.

125

CREATIVE CHANGES

Create a Transition

You can blend a scene with something related to it that is printed large on paper (a map, dress pattern, house or garden plans, city street layout, etc.). This involves overlapping one image with another.

With watercolors, this is easy—but it takes nerve. Paint one image and fade it out in one direction, blotting as needed or lifting with a damp sponge after the paint is dry. When this is dry, paint the second image toward the first and, again, fade it out with water or blotting. To avoid blurring the bottom layer, avoid aggressive brushwork on this layer. Note: Transparent colors are recommended. Experiment with staining and non-staining paints.

THE CHALLENGE
There is more than one way of blending two types of images into each other in this way. Images could blend vertically, horizontally, diagonally, along a curving line, from the center out, and so on. Can you find some ways of your own?

MISSISSAGI RIVER COUNTRY
11" × 14" (28cm × 36cm)

COMBINING TWO VERSIONS OF THE SAME PLACE
In this picture, the paper is divided into four unequal pieces with narrow tape. The landscape that occupies the upper right quadrant fades to the left and downward. The map that occupies the lower left quadrant fades upward and to the right. It doesn't really matter which you do first.

CREATIVE CHANGES

Change the Shape of Your Picture

Try using the shape of a large object or group of objects as the "container" for a related scene. It's important to choose a container shape that is recognizable by its contour. What would the contents be if the container was a butterfly? A sail boat? A tool shed? A tour bus? Perhaps you have a photo of something that would make good "contents" for a shape. Now let your imagination create a shape for it.

FLOWERS OF THE FOREST
14" × 22" (36cm × 56cm)

NOW YOUR PICTURE IS A PICTURE
In this painting, the area around the shape of a group of wildflowers was carefully masked out with drawing gum. (This is called negative masking.) When the gum was dry, I freely painted a forest scene in the middle. When the gum was removed, the shape of the flowers contained a forest.

CREATIVE CHANGES

Incorporate Humor or Alternate Meaning

Why is it that humor has such a hard time in the arts, especially the visual arts? At least on stage and in literature, movies, television and even opera, humor is accepted—not necessarily rewarded, but accepted as a variant—but in the visual arts, one dare not smile or snicker, lest their work be deemed irrelevant. What a shame to deny basic human nature.

When was the last time you heard laughter coming from an art gallery? Even a friend of mine once commented, "There is more humor on an accountant's ledger than on the walls of the average art museum." Why is that? When did we visual artists agree to take on such a somber, humorless outlook on life?

It's something to think on, and while you are, consider how profound and unique it is as a human gift to be able to put simple marks on a piece of paper, a cathedral ceiling or a cave wall that will bring forth spontaneous laughter from deep within our soul even as they are being drawn. How good that feels. How healthy that feels. I think the creative spirit has a sense of humor for our own good. Shouldn't we be honoring it? Shouldn't we occasionally incorporate humor into our art if we so desire?

I'm not advocating a mass belly-laughing movement, but perhaps just the inclusion of some subtle visual satire, double meaning, or a clever retake on traditions is in order. In other words, don't be afraid to use your images to imply alternate meaning, to suggest the true nature of your subject or to create unexpected scenarios. Remember, the most lasting humor is intellectual and subtle. Remember also that sometimes a complex concept can be conveyed and is remembered far better through humor. Teachers know this. That's why cartoons are in this book.

I believe that dabbling in some form of humor, even if you are the only one laughing, is good for the gray cells.

That's where caricatures come in. They represent the first gentle step toward humor. A caricature is the exaggeration or abstraction of the main features of your subject and stylization of its shape. Try developing caricatures of man-made objects first. This will give you a much-needed break from all that serious stuff by freeing you to push your creative daring.

Don't be mistaken—caricatures require all the skill and techniques you'd use in a more sober painting, but they are applied for a more playful purpose. The background for these shapes is often simplified.

PHOTO REALITY
Made by Piaggio, Europe's three-wheeled mini workhorse.

AND AWAY WE GO!
A Piaggio truck, redrawn as a caricature. Angling the subject or drawing structures out of square will add energy, charm and movement to the subject.

DEVELOPING A CARICATURE

Developing a caricature often requires much sketching and re-sketching of the subject until you develop something that speaks of the object's nature or personality. When you start chuckling to yourself, you know you're on the right path. Here's a method I use so that I don't have to keep erasing and redrawing my shapes.

1. Draw the subject as-is
Find a small notepad with lightweight paper in it. Open about five to six pages. Draw the subject as-is with a ballpoint pen or fine black marker.

2. Redraw with exaggerations
When I lower one of the blank pages, I'm able to faintly see the original drawing underneath it. I redraw my subject with exaggerations to its shape and position. When finished, I lower another page and continue to refine my subject from the one just done. This is repeated until I have something I want to pursue as a painting.

STAY TRUE TO YOUR STYLE

A person's "style" of caricature is as unique as their handwriting. The style of many serious artists is just a mild form of caricaturing that gives their shapes and lines a distinctively personal "charm" or "character." This is important. The maker should be obvious by their work.

I once witnessed a scenario in which artists exhibiting at an art fair over the years worked very hard to achieve super-realism in their work. Unfortunately, the more successful they were, the more they all looked alike. Personal "style" had been sterilized so badly that the makers of the paintings were identifiable only by their signatures. We must remember to include ourselves in our work.

POWER SUMMIT
11" × 14" (28cm × 36cm)

CARICATURES CAN GO BEYOND SINGLE CHARACTERS
Sometimes a whole scenario or event can be caricaturized and carry deeper meaning.

8 Passing On the Spirit by Teaching Others

A good number of former students have turned to teaching as part of their creative growth. Likewise, it is a part of my path of over fifty years in front of a class to pass on some tips about this noble endeavor.

AQUARIAN LACE
22" × 15" (56cm × 38cm)

Learning to Teach, and Teaching to Learn

Actually, there is no better way to learn than to teach. Those who go into it, no matter how long they have been painting, notice a decided improvement in the depth and breadth of their understanding of the watercolor processes and the fundamentals of art design. It forces them to think through the problems that they and other painters have and devise ways to help their new students in those areas.

The following thoughts and discoveries that I've made while instructing others might help you along your own path if you should decide to take up a teaching role.

- **Expect the teacher to become the student.** The term "student" is used here only to denote the people or participants doing the learning and "teacher" as the one imparting knowledge. Quite often these roles are reversed, so be prepared to learn from your students.
- **Remember that you are teaching individuals.** You will discover that every person is unique and has their own way of seeing things. You never had to think of that before, but it will affect how and what you teach.
- **Lighten up.** Keep your sense of humor. It's your best body armor and way to meet your students on a personal level. Make fun of yourself. If the class is laughing, you will relax.
- **Be honest.** Let them know that you too have struggled and are still searching and learning, and that you are there to share what you have discovered over the years that will help them navigate the wonders and pitfalls of watercolors.
- **Admit that you make mistakes** (one of which might be teaching them). But, the important thing you have learned in doing so is how to respond to problems—how to roll with the punches, change directions on a dime and keep on going.
- **Make sure your students know that it's OK to take chances and make mistakes.** It's how we learn, but unless they see you take an innovative chance or even fail under pressure, there may be little incentive for them to take chances. Some of your best lessons will be how to accept and deal with failure. Besides, any piece that doesn't work can always be called a spontaneous experiment or preliminary prototype or initial field study.
- **Be open.** Respect the ideas and honest attempts of all, even if it doesn't look as good as you expected.

Nothing you show your students is theirs until they use it in their own pictures in their own way.

Further Down the Teaching Trail

As you enter the teaching field you will make many discoveries of your own that will make your task easier. Here are a few more of my own that I would like to share with you.

- **Watercolors are unique in that the attitude of the artist is very important.** Students must learn to be forgiving, flexible, accept the fact that things will not always work their way, and be willing in some cases to let the medium do the painting while they keep their hands off. There is no room for a domineering attitude in watercolors. You can lead by example by trying to maintain a positive, open, curious, nonjudgmental outlook.
- **Teaching is trial by fire.** Even though you may cultivate a quiet, confident, professional exterior while demonstrating, only you will know the sheer terror, doubt and uncertainty that sometimes rages inside you. You may never completely overcome this, but like performers, you learn to live with it. You might even discover your own form of prayer. You will undoubtedly grow stronger and freer to learn right along with your students.
- **There is no magic to teaching.** All you have to do is build some lessons around questions that the students haven't asked yet. That means not just showcasing what you can do as an experienced artist and letting your students sink or swim, but using what you can do as an experienced artist to help them grow in areas where you think they need help. This means first getting to know roughly what experience they have.
- **I have always used their palettes as an early indicator.** If a student has a large palette with a good quantity of paint in the wells and if there is sign that it has been used recently, I know that they are probably an active, experienced painter and can take anything I throw at them. If their palette is small with tiny wells, I know that they don't have experience with big brushes or being loose and spontaneous in their approach and use mainly one or two brushes. If the wells have hardly any paint in them or are empty and they have bags of assorted tiny tubes of paint, I know that they probably don't paint regularly, haven't mastered many basic skills such as negative painting, and also use one or two brushes for almost everything.
- **Your task is to present picture ideas that provide exercise in specific skills or procedures for those with some experience while offering variations to challenge the more experienced.** This is not that hard. For example, many painting ideas can be broken down into foreground, middle ground and background. Let's suppose this time the skill to be used is mingling colors. If each person is allowed to mingle colors in those areas in their own way, each can rise to the best of their ability.
- **Many times there are areas in a painting that each student can paint as they wish so long as they meet a particular objective.** If an area in a painting is to be a dark forest in the background, the quality of the trees can vary according to ability. What matters to the picture is that the trees are dark and that they are in the background. The more advanced painter will instinctively do more.
- **Your demonstration is just the first step in the learning process.** It's important that each person feel they have fair backup from you as they work on their own. I admit that I am guilty of seemingly ignoring some folks who have the amazing ability to fade into the background in a class, especially when others want to steal all my attention. I sincerely apologize to them. For you, the warning is to watch out for your invisible students. Check the shadows.
- **Many beginners will make mention of how they are seeing so much more around them since they started painting.** This is a wonderful gift courtesy of the drawing/painting process. Acknowledge this. Celebrate it, and point out that so long as they keep creating images, the world will continue to open up its visual wonders to them. Every day I give thanks for seeing something new for my soul and a challenge for a painting.

The Painting Process: Setting the Stage

One of the most valuable things that you will be teaching your students is how important it is to focus your attention on the painting process. If you were just painting your bedroom walls this would not matter, but you are in the process of creating something that is new and unique to you and it requires your undivided attention. Explain that, ideally, what they want to set up is a quiet, private little world between themselves and their painting. Explain that this creative world that they will be involved in is a right-brain, nonverbal domain that is easily disrupted with talking, and that you would like them to try to experience that domain whenever they or you are painting.

Explain, as an example, that you need to concentrate when you demonstrate, and it would help if they would please hold their questions until there is a break. Explain also that you don't mind them talking amongst themselves so long as they're talking quietly and about the demo, not last night's TV show.

What you are doing is setting the norm for your workshop. When it is their turn to paint, encourage them to experience that quiet creative bubble by focusing on their work and avoiding idle chit-chat.

There is an old teaching poster that says, "If you're talking, you're not listening." I would alter that to read, "If you're talking, you can't hear what your painting is trying to tell you." We call this private conversation "intuition," and it can be your greatest ally if you can hear it.

One of the things I have done in my workshops to help fill the silence that some feel compelled to fill with

If your students are taking notes, it is very important that they dedicate a page or two to each painting rather than jotting continual notes that won't make sense in the end because you'll not know which painting they refer to.

babble is play soft instrumental music. It easily fills that silent void that many today find unnerving.

However, the very best way to create a quiet creative atmosphere is to keep everyone really busy.

This brings me to a method that I use in workshops where the students work on several paintings at a time. If they finish work on one, then they can switch to another to work on. This requires at least four lightweight boards on which to tape their paper.

I prefer quarter-sheet paper because they can experience and learn more by working on four to five smaller paintings in two days than working two half sheets in the same time.

My planning before the workshop involves determining the skills and procedures that I think the students would benefit from. These are usually based on a broad topic, such as Atmosphere, Creating Energy in your Paintings, Passages, etc. I then develop some ideas for pictures based on that topic that will incorporate those skills. I choose types of pictures that leave room for lots of variation by the students. They're simply forums for them to try out a new skill or procedure. Importantly, I consider how each picture can be done in stages.

Here is how it works: I demo a portion of a painting, and then the students go back to their spots and do their version. After a reasonable amount of time I demo a part on the next picture, and so on. The working time in between demos is governed by the talking level. If the level goes up, I know they're ready for the next step in a demo.

This is a simplified example of how it works:
- Picture 1: discuss painting, paint background, set aside to dry
- Picture 2: discuss painting, paint background, set aside to dry
- Picture 3: mask out some aspect; if gum was used, set it aside to dry
- Picture 1: do something about the middle ground, let dry
- Picture 2: do some negative painting, let dry
- Because 3 is still wet, start picture 4: mingled passage for background, let dry
- Picture 2: more negative painting, let dry
- Picture 1: add detail in foreground, let dry
- . . . and so on

This is just multitasking in slow motion. Just don't start too many paintings, as I have on occasion, or you'll not finish them all. Your students will be so busy that the room will have a magical silence when they're working. You can almost feel the energy crackling.

The Learning Process: Helping It Stick

Most of our learning is done by either imitation or experimentation. Repetition and use of what we have copied or discovered helps consolidate that knowledge. It also leads to new variations and further discoveries.

I often tell my classes that what they learn from my workshop depends on what they do next week. If they go home and put away their paints, everything is lost. If they go home and repeat the techniques and picture-making processes they were shown, but in their own way, then the knowledge will be theirs.

WHAT I HAVE LEARNED: TWO WAYS TO DEMO

There are two ways to demo a painting.

The first way is to paint the whole picture from beginning to end with little interruption. This allows you to get fully involved with the painting process no matter how long it takes. Usually you don't have to do a lot of talking and you believe that the students will learn by just seeing you create a wonderful, saleable painting.

From the students' point of view, they are very glad when this long, boring process is over. They are eager to paint but are usually in a quandary as to what to do first or next unless they have made really good notes. (Very little is retained without them.)

This demo approach is based on the same theory that watching a figure skater long enough will make you one.

The other way is to do your demo in stages, with time in between for the students to do some of their own

GRAPES OF WRATH
15" × 22" (38cm × 56cm)

Through experimentation I once learned how to make wine from wild grapes.

work. I believe that they will learn faster and retain more if watching or listening is combined with doing, and if that doing is done in small bites.

It also helps tremendously if before you paint each stage of your demo, you first demonstrate any relevant skill or technique that you may want them to try in the next stage.

IN GENERAL . . .

Think of every picture you want to demo as a collection of individual skills and procedures that the students can benefit from. Procedures are the steps or processes used to produce an effect—for example, painting rushing rapids or a stormy sky. Procedures involve a number of skills.

I've discovered that students will learn more and faster if:

1. The picture they'll be painting contains one or two major skills or a procedure they would benefit from. (See "Some Basic Watercolor Techniques" later in this chapter.)
2. They have a chance to use a particular skill or technique repeatedly in the same picture—for instance, learning how to fade out the edge of a paint mark to create clouds, hills or rocks.
3. A particular skill or technique is used for several different jobs—for example, using a sponge for trees, moss, bark, clouds, etc. (not all in the same picture).
4. You create a different effect by making simple variations in

a technique or procedure, such as changing the brush used for making trees, using a sponge to apply masking fluid instead of a paint brush, or using an eye dropper instead of a brush to drop in paint or water. This is a rich field for them to experiment and explore in. Most techniques are variations on one another.

5. They take the time to practice a technique or skill before going to a painting. Inexpensive paper can be useful here.

6. You, while walking around the class, detect something they are having a problem with or think of a way to enhance what they are doing, then take the time right then to show them in a mini lesson.

7. You explain the stages or steps in making the picture before they start. Having the Big Picture in their head helps.

8. Every picture has some sort of challenge or problem to resolve. This will provide an opportunity for them to partake of the creative process by using their imagination, intuition and ingenuity to find solutions. You will be involving them in a process and mind-set that will be with them all of their painting days.

9. You compliment them on their successes, no matter how small, and always measure their attempts against their abilities, not yours or anyone else's.

10. You explain how each brush is suited to do certain jobs really well but no brush can do them all. Basically, all brushes are variations on round or flat. Each variant shape allows you to make a unique range of marks. A brush's bristle makeup, which is either synthetic, natural or a mix of these, determines the character or quality of the mark and the retention and flow of the paint. Basically you want to discourage the use of a single brush to paint everything. That's like a carpenter using a hammer for all jobs. Encourage them to "test drive" all their brushes to see what they can do with them by the way they hold, move and apply paint. (For more on brushes, see pages 18–20 in my book *The Watercolorist's Essential Notebook*).

11. You respect their ideas, questions and every honest attempt, even if it doesn't look as you had hoped. Often the results of a project will tell you what to teach or re-teach next. I have often repeated a demo because my teaching wasn't good enough the first time.

IMPOSTER DOWN
15" × 22" (38cm × 56cm)
The challenge in this type of downward-view painting was to find a method that would suggest the optics of looking through water and seeing the light pattern from the waves above on the bottom below.

The Mechanics of Setting Up a Workshop

For starters, make it fun. GET EXCITED about sharing what you know about this most ancient of mediums: water and pigments. They have captivated artists for thousands of years.

Start small—three to four friends, perhaps in your home. Eventually move up to renting small spaces and then larger ones as your fame and reputation spreads.

What you will need, regardless of class size:

- a source of water
- good lighting, natural if possible (Warning: Fluorescent lights like the ones in clothing stores can seriously distort your colors.)
- sufficient work space. Watercolorists need more surface space than artists working in oils or acrylics because they work horizontally. You'll need at least 4 feet (1.2m) long by 30 inches (76cm) deep or more per person. Folding tables are standard furniture.
- a restroom/washroom
- an area for refreshments

GATHER AROUND

Personally, I prefer to have my students gather around when I am teaching or demonstrating. This removes them from the distractions of their work space and allows them to see techniques close up. It also creates a more friendly, intimate bond within the whole group. One of the most important things in a workshop is creating an "energy" in the room that everyone can feed off of. I believe these opportunities to gather around during demos or discussions help nurture that energy. Physically you may need additional chairs around the demonstration area. Overhead mirrors are great if the students are close enough; viewing from a distance in a mirror won't provide that closeup view they need for many techniques. Even an overhead camera doesn't work unless you have a zoom-in view and a normal view on a double or split screen.

SOME THOUGHTS ON SUPPLIES FOR BEGINNERS

Paper. Paper quality helps to determine your success, so use good paper right from the start. Inexpensive, poor-quality paper will definitely work against your students. It will give them the idea that they can't paint. Beginner classes need only work on eighth-sheet size (7½" x 11" [19cm x 28cm]) until they have some experience with basic techniques; then move up to quarter sheet (11" x 15" [28cm x 38cm]), then half sheet (15" x 22" [38cm x 56cm]). I recommend 140-lb. (300gsm) Arches sheets for all levels. If you are using cut-up sheets of paper, you will need some lightweight boards on which to tape them.

Paint. You can mix a tremendous range of colors from these four pigments: 1) Ultramarine Blue, 2) Indian Yellow or Aureolin, 3) Permanent Rose or Red Rose Deep or Alizarin Crimson, and 4) Burnt Sienna or Quinacridone Burnt Orange.

Palettes. I suggest using white styrofoam meat trays as beginner palettes. Then if they get serious about watercolors, they can start looking for a commercial palette. Encourage them to buy one that has large, flat rectangular wells for colors. The next best is large, sloped rectangular wells. They can put out a good quantity of paint on these and let it harden. Avoid small palettes with circular wells.

Starter brushes. I suggest no. 6 and no. 10 synthetic rounds, an inexpensive ¾-inch (19mm) to 1-inch (25mm) flat hog bristle brush (an acrylic brush with the handle cut off), and a 1-inch (25mm) to 1½-inch (38mm) flat hog bristle brush. A flat synthetic brush with long bristles will also be handy.

Synthetic brushes are like race horses, smooth and sleek. Their marks are sharp-edged but they don't carry much.

Natural hog bristle brushes are not found with other watercolor brushes. They are your work horses that can dig up and carry lots of paint and put it down in rough, irregular marks.

And so, by simply having people gather around, even standing behind me, they get the best view they can at no extra cost.

Some Basic Watercolor Techniques

Even experienced artists may have gaps in their skill set. Here are some really basic watercolor painting skills that every painter should have under their control.

- **Mixing colors on your palette:** If using a palette with hardened paint, it is wasteful and counterproductive to wash your brush every time you go to get more color to add to a mixture. For example, if you want to mix red and blue and you have already lifted a load of blue from its well and put it on your palette, there is no need to wash your brush before you get some red. Simply go to the red and scrub up some color with your "dirty" brush and bring it back to mix with the blue on the palette. The sky will not fall in. If desired, add a touch of water to the mixture now, or a little more blue, or red, as you fine-tune the mixture. The dirty palette wells can be cleaned later with a damp brush if necessary. Clean your brush when you want to use a single clean color or want to change mixtures.
- **Mixing a concentrated dark color:** Mix as above but don't keep adding water, since this only thins out your mixture.
- **The order of mixing colors:** Mix a small quantity of dark color into the light color. If you reverse this, you will end up with far more paint than needed.
- **Making use of different wetnesses:** Drop or brush water or wet color into damp paint. The new water or paint will push the damp base color aside, causing intentional run-backs. This is one way to paint light color on top of dark.
- **Painting a graded wash:** Start with color at one end. Paint three to four long strokes across the area with a wide brush. Dip the brush in water and wipe twice on the side of the water container, and then return to the wash and continue painting three to four strokes. Repeat, dipping your brush in the water and wiping twice before going back to the painting. What's happening? Every time you dip and wipe your brush twice, you reduce the pigment and water on the brush by just the amount needed to grade the wash you're painting.
- **Fading out a color:** The edge of a painted shape can be faded out (or softened) by running a damp brush along its edge while it is still wet. Alternately, you could wet the paper and then tickle the edge of this wet area with a brush loaded with the color you want to fade out. The wet paper will absorb the paint off the brush.
- **Blending two colors together into a gradation:** Lay the first color (ex: red) about three-quarters of the way from one end toward the other using broad strokes. Immediately load with the second color (ex: blue) and paint toward and over the red until three-quarters of the way. Reverse direction and work back toward the blue end without lifting the brush. Go until the color blends smoothly into the blue and then reverse direction again and blend the red end. Note: Once you start blending, do not lift the brush from the paper.
- **Lifting color with a brush:** You can lift wet paint from paper, so long as the brush lifting is drier than the paint.
- **Letting the paint and water do the work:** Learn to do nothing except watch what the paint and water can do without your help.
- **Learning to see and paint shapes in the negative:** All this means is learning to define a shape by painting its background instead of the shape itself. Negative shapes in a painting add reality and variety.
- **Making a shape with single strokes as opposed to outlining and filling in with color:** This "painterly" approach (rather than coloring book blindness) is the result of knowing brush techniques—discovering what your brush can do by varying the pressure on it while holding and moving it in different ways. Encourage your students to use a brush like a broom, not a mop or a crayon.

Many will believe that you secretly use magic colors, but it's just a rumor.

About Your Students

Freedom of thought and expression are prerequisites to the creative process. This may come as a terrifying shock to some who have wandered into this area believing that someone else would do all their thinking for them. These are folks who have never, in an art class, had the opportunity to deviate from the path, be innovative, solve their own visual problems or decide what "looks right" to them and stick with it.

The people coming to you are expecting to learn something. The beginners are hoping to learn how to make a painting that looks just like yours and will gleefully try to copy whatever you do. There is nothing wrong with learning by imitation. It is a valid way for anyone to learn something new. However, after a while copiers should be nudged into making their own variations and putting to use what they are imitating in entirely different ways. This is how they grow. (You may be creating monsters.)

Another valid way to learn is experimentation, sometimes called "play." In watercolors the nature of the medium must be understood to be used effectively. Even though it is just pigments and water, the effects you can get by varying the moisture conditions and tools is amazing, and it is all there for discovery through play (but you can call it "research"). Students can learn much about the medium if you point out how and why certain effects happen in your demos. Encourage them to take the attitude that each painting is a chance to experiment and discover something new about the medium.

Make sure your students know it's OK to develop their skills through experimentation (play).

Repetition will instill what has been learned. Personal variation will make it theirs.

Those who are coming to you who have taken a number of workshops, seminars or classes are not there to copy your picture but to witness your techniques and procedures for getting the effects you do and the approaches to composition you use. They want to know how to use color and shapes and lines and values to effectively enhance their own pictures.

Most of your students will fall somewhere in between "beginner" and "lifetime learner."

A Final Thought

Our greatest gift as humans is the ability to create. This power to bring into existence something from our imagination that never existed before is profound. It reaches to the essence of who we are as a species and our connection to a universal consciousness.

Those who come back from their places along the creative path to help others grow are called teachers. At some point it is hoped that you will take your turn and watch with great satisfaction as your students build bridges to their own higher selves while letting your light shine through them.

PRISTINE
19" × 22" (48cm × 56cm)

Water, the source of all life, flows endlessly through our bodies, our dreams, and our lives. How appropriate it is, with a little pigment, to be a medium for the inhabitants of this planet.

Index

adhesives, 125
angles, 21–22, 25, 70
atmospherics, 13, 17, 20–21, 73–83, 109

backgrounds, 18, 91
 graded, 74, 80, 137
 interchanging, 119
 mottled, 74, 77–79
 solid, 74–76
balance, 13–15, 21, 104, 109
blending, 87, 126, 137
blotting, 87, 90
body language, 23
brush technique, 137
brushes, for fog, 74
brushstrokes, for body shapes, 85

caricatures, 129
cast shadows, 50–51, 53, 58–59. See also shadows
center of interest, 13, 39, 41, 49, 108
challenge, 8–9
collage, 123, 125
color(s)
 analogous, 34
 and atmosphere, 20
 background, 91
 changing, 109
 characteristics of, 37
 complementary, 14–15, 29–30, 34, 38
 concentrated, 30, 137
 contrast of, 18
 dark, 30
 dropping, 61
 eye-grabbing, 29
 fading out, 137
 light, 30
 and light, 29
 mingling, 14, 60–64, 105, 109
 mixing, 30, 104, 137
 muted, 39
 permanence of, 37
 primary, 34, 36
 saturated, 33
 selecting, 31–32, 36–38
 staining ability of, 37
 transparency of, 37
 transparent, 63, 126
 unsaturated, 33, 38
color dominance, 29
color harmony, 105
color palette, 14, 33
color schemes, 34–38, 104–105
color temperature, 14, 16, 18, 21, 29, 37, 104
color wheel, 33
composition, 12–13
 improving, 106–107
contrast, 13, 15–16, 21, 49
 of color, 18
 of line (edges), 18, 61
 of shape, 18
 of values, 17, 30, 47, 61, 108
creative process, 6–11
creativity, 139
 alternate meanings, 128–129
 changing shape of picture, 127
 combining paper elements, 123, 125
 creating transition(s), 47–56, 99, 126
 using humor, 128
 See also photographs
cropping, 110–111
cross sections, 120

damp-on-wet, 109
design, elements of, 13–14
 color, 13–15
 line, 13–15
 shape, 13–15
 value, 13–16
design, principles of
 balance, 13–15, 21, 104, 109
 contrast, 13, 15–16, 21, 49
 emphasis (dominance), 13–15
 gradation, 13, 47–56, 103, 109, 137
 mood, 13–14, 16, 29
 movement, 13, 14, 17, 21–22, 108
 pattern, 14, 27–28
 perspective, 13–14, 115
 rhythm, 13
 transitions, 13, 47–56, 99, 126
 unity, 13–15, 29, 109
 variety, 13–14
 visual effects, 14
 See also contrast
detail, 102
drama, 19, 94, 103
drawing gum, 127. See also masking
dropping color, 61

edges (line), 21–22
 contrast of, 18, 61
 hard, 18–19, 125
 soft, 18–20
emphasis, 13–15
energy, 22

fading out, 137
figures
 adding, 109
 adding colors for clothing, 89
 adding detail to, 91
 bending limbs, 86
 in crowds, 91
 distinguishing, 88
 with hats, 90
 implying movement, 86
 painting, 85–87
 positive and negative, 90
 proportions, 86, 88
 running, 88
 walking, 88
focal point, 13, 24–25, 39, 77
fog, 73–83
formats, 24–28
 big and small, 27
 box/oval, 24
 bridge, 26
 criteria for, 25
 framing, 26–27
 hook/spiral, 25
 multiple paths, 24
 variable repetition, 28
 zigzag path, 24–25
framework, 109

glazing, 75, 122
gradation, 13, 47–56, 103, 109, 137

hatching marks, 102
highlights, 87, 103
hook/spiral path, 25

hue, 18, 33, 37

imagination, 66
inspiration, 6–11
intensity, 18, 37
intuition, 9–11, 35, 45

lifting, 73, 126, 137
light
 and color, 29
 vs. dark, 30
 quality of, 98
light sources, 97
lighting, 108
 front lighting, 53
lights
 saving, 74
 See also masking
line. *See* edges (line)

masking, 68, 70, 74, 80–81, 116–117
 negative, 127
 See also drawing gum
masking fluid, 52–53
mingling, 14, 60–64, 105, 109
mood, 13–14, 16, 29
movement, 13, 14, 17, 21–22, 108

negative masking, 127
negative painting, 55, 58–59, 68, 90, 122
negative shapes, 102, 137
negative space, 57–59

outlines, 69, 102

painterly approach, 137
painting process, 133
painting(s)
 compared to stage plays, 41–44
 negative, 55, 58–59, 68, 90, 122
 positive, 55, 58–59, 68, 122
paper materials, 123, 125
passages, 60, 65–68, 70–71
paths, 24–25
patterns, 14, 27–28, 61, 63, 67–68, 74, 83, 100, 106, 116–117, 125
pecking order, 39–40
people. *See* figures
perspective, 13–14, 115

photographs
 adding a distinct color scheme, 104–105
 adding a transparent element, 122–123
 adding drama to, 94
 adding outlines, shading, texture, and detail, 102
 adding shadows, 100
 changing point of view, 113–117
 changing scale and situation, 121
 changing shape of, 127
 changing the atmosphere, 98
 changing the season, 99
 changing the time of day, 97
 combining, 118–120
 exaggerating, 112
 flipping, 96
 highlighting an important area, 103
 refurbishing, 112
 tilting, 95
 varying the value arrangement, 101
 working with, 13, 92–93
 zooming and cropping, 110–111
pigments, 36–38, 61–62, 136–138
point of view
 from above or below, 115
 changing, 113–117
 front and center, 117
 looking up, 116
pointing, 23
positive painting, 55, 58–59, 68, 122
positive shapes, 57–59, 67, 102
reference photos. *See* photographs
reflections, 15, 49, 54, 75, 83, 97, 108–109
repetition, 28. *See also* patterns
reversal, 47, 58, 109
rhythm, 14

sandpaper, 77, 82
scrubbing, 79, 83, 117, 123–124
shading, 102
shadows, 20, 30, 53, 68, 75, 97–98, 108–109
 cast, 50–51, 53, 58–59
 creating by removing paint, 100
 internal, 117

shape(s), 21
 contrast of, 18
 negative, 102, 137
 positive, 57–59, 67, 102
signs, 40
space
 division of, 108
 negative, 57–59
spattering, 61–62
sprayers, 66
students, 138
style, personal, 129
subliminal messages, 23
suggestion, 65
symbols, 40, 123

taping, 123
teaching, 130–133
 suggestions for, 134–135
 two ways to demo, 134
temperature. *See* color temperature
texture, 53, 102, 125
thumbnail sketches, 106–107
tints, 30
toothbrush, 62
transitions, 13, 47–56, 99, 126

unity, 13–15, 29, 109

value(s), 18, 109
 adjusting, 47
 changing, 119–120
 contrast in, 17, 30, 47, 61, 108
 differences in, 69
visual perception, 17

washes, 48, 61, 69, 116
 graded, 137
 See also backgrounds
watercolor techniques, 137
wet in wet, 61
wet on dry, 62
wet-on-damp, 61, 109
wet-on-partially wet, 109
wet-on-wet, 109
words, adding, 40
workshops, 136

zigzag path, 24–25
zooming, 110–111

The Watercolorist's Essential Notebook: Keep Painting! Copyright © 2017 by Gordon MacKenzie. Manufactured in China. All rights reserved. No part of this book may be reproduced in any form or by any electronic or mechanical means including information storage and retrieval systems without permission in writing from the publisher, except by a reviewer who may quote brief passages in a review. Published by North Light Books, an imprint of F+W Media, Inc., 10151 Carver Road, Suite 200, Blue Ash, Ohio, 45242. (800) 289-0963. First Edition.

fwmedia.com

23 22 21 20 19 6 5 4 3 2

fw a content + ecommerce company

DISTRIBUTED IN THE U.K. AND EUROPE
BY F&W MEDIA INTERNATIONAL LTD
Pynes Hill Court, Pynes Hill, Rydon Lane, Exeter, EX2 5SP, UK
Tel: (+44) 1392 797680
Email: enquiries@fwmedia.com

ISBN 978-1-4403-4877-8

Edited by Stefanie Laufersweiler
Production edited by Amy Jones and Jennifer Zellner
Designed by Michelle Thompson
Production Design by Jamie DeAnne
Cover Design by Geoff Raker and Jamie DeAnne
Production coordinated by Jennifer Bass

Dedication

For my sister, Vera, a kindred soul who gave me my first paints, and my brother, Don, a fellow artist who carves miracles from wood.

Acknowledgments

I wish to thank all my students who have taught me much about teaching over the years, and especially those who helped proofread sections of this book. Those people I tried to ignore. Just kidding. I truly appreciate their kind suggestions and support. A special thanks to Ken Oliver for transferring data and Stefanie Laufersweiler for sorting it out.

METRIC CONVERSION CHART

To convert	to	multiply by
Inches	Centimeters	2.54
Centimeters	Inches	0.4
Feet	Centimeters	30.5
Centimeters	Feet	0.03
Yards	Meters	0.9
Meters	Yards	1.1

About the Author

Formal art education in the remote northern town of New Liskeard, Ontario, was not an option for Gordon MacKenzie, but that was not necessarily a bad thing. What it did was teach Gordon how to solve his painting problems on his own and how to apply his ingenuity when supplies and support were limited. Those essential creative processing skills he developed would serve him well in years to come. Most importantly, in retrospect, the remoteness of his home gave him the opportunity to really see and develop an emotional bond with the natural world. It became the inspiration and driving force behind his work.

"The experience of the north through all seasons is something not easily forgotten," says Gordon. "Here the Spirit of remote lakes, rivers and hills speaks in breathtaking images for the eye and timeless silence for the soul. For an honest interpretation of this pristine ruggedness, the artist must let the land teach the lessons of rebirth, both physical and spiritual. The more I looked into nature, the more I discovered my own self."

His current residence in Sault Ste. Marie, Ontario, heart of Algoma District in a Group of Seven country, allows him to maintain his closeness to the outdoors. In his long career as an art educator, Gordon taught students from kindergarten to university level and though he has been retired for over twenty years, he has never stopped teaching. Since his retirement, his reputation as a fine instructor and demand for his painting seminars have caused him to change his focus from painting for exhibitions, competitions and galleries to using his teaching skills to help other artists discover the magic of watercolors.

"It's not as glamorous a route as exhibiting and competing," he says, "and I won't become wildly famous for my work, but I feel that this is the path I am intended to be on, one that makes others wildly famous."

From when he started teaching workshops, Gordon estimates that he has taught over forty-five hundred students in over sixty locations in five countries. Now with his three books and his instructional videos, he extends that teaching worldwide. He says, "What I've discovered in my travels and teaching is that no one area, urban in particular, has a monopoly on creative achievement," and adds, "Some of the finest artists I've come across and those who generally exhibit a higher level of creative ability are working in small, often isolated, centers."

Apparently having all the benefits of an urban center is no guarantee of cornering the market on creative growth. We are all equal.

The considerable amount of time spent preparing for workshops reflects his teaching ethic that demands that student learning come first. "I want to do more than show up and paint some nice pictures to sell while leaving the students to learn whatever they can on their own," Gordon says. "I want them to learn things they can actually use in their own way while demonstrating ways in which they can grow their own wings."

This book is an extension of that philosophy.

For more about Gordon and his latest offerings and happenings, visit www.gordonmackenziewatercolours.com.

Ideas. Instruction. Inspiration.

Receive FREE downloadable bonus materials when you sign up for our free newsletter at artistsnetwork.com/Newsletter_Thanks.

These and other fine North Light products are available at your favorite art & craft retailer, bookstore or online supplier. Visit our websites at artistsnetwork.com and artistsnetwork.tv.

Find the latest issues of Watercolor Artist on newsstands, or visit artistsnetwork.com.

Follow North Light Books for the latest news, free wallpapers, free demos and chances to win FREE BOOKS!

Get your art in print!

Visit artistsnetwork.com/splashwatercolor for up-to-date information on Splash and other North Light competitions.